BASEBALL
ON CAPE COD

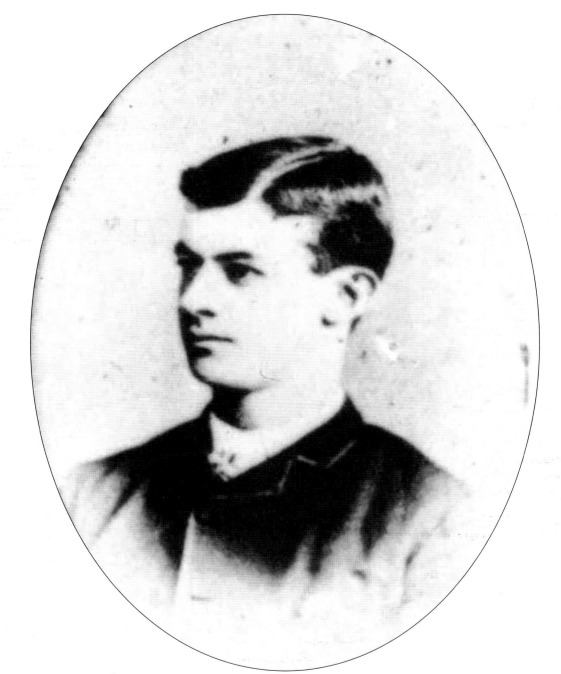

Born in Sandwich in 1864, Ed Conley was the first native-born Cape Codder to play locally before moving on to the major leagues. Conley pitched eight games for the Providence Grays in 1884, compiling a record of 4-4. The Grays were the first world champions that year, the only season Conley played for them. His move from the Cape to the major leagues blazed a trail that hundreds of ballplayers would follow. (Courtesy National Baseball Hall of Fame Library, Cooperstown, New York.)

BASEBALL ON CAPE COD

Dan Crowley

ARCADIA

First published 2004
Reprinted 2004

Published by Arcadia Publishing
Charleston SC, Chicago IL, Portsmouth NH, San Francisco CA

Printed in Great Britain

Library of Congress Catalog Card Number: 2003116943

For all general information, contact Arcadia Publishing:
Telephone 843-853-2070
Fax 843-853-0044
E-mail sales@arcadiapublishing.com
For customer service and orders:
Toll-free 1-888-313-2665

Visit us on the Internet at www.arcadiapublishing.com

Organized baseball began on Cape Cod in 1865 with the formation of the Nichols Club, named in honor of sea captain Edward Nichols, who offered his field for the team's use. Other teams quickly sprang up, beginning a tradition of baseball on Cape Cod that has grown into today's Cape Cod Baseball League, the premier summer collegiate league in the nation. (Courtesy Sean Walsh.)

CONTENTS

Acknowledgments 6

Introduction 7

1. Town Ball and the Growth of the Game: 1865–1922 9

2. The Early Cape League: 1923–1939 29

3. The Upper and Lower Cape League Years: 1940–1962 43

4. The Modern Era Begins: 1963–1987 65

5. Expansion and the 1990s: 1988–1999 89

6. The New Century: 2000–2003 109

ACKNOWLEDGMENTS

In my search across Cape Cod for photographs that chronicled the growth of organized baseball, I had the opportunity to meet and talk with some of the nicest people associated with the game. From the players whose memories stretched back to the 1920s to the people that make today's Cape Cod Baseball League run, it has been a trip down memory lane.

There have been many people who helped me in putting this book together, but in the end it simply would not have been possible without the able assistance of Cape Cod Baseball League historian Bruce Hack. When it comes to the Cape League, there are few more versed in its history and lore. The league is fortunate to have him, and I was fortunate to have his help.

I owe a debt of appreciation to Dan Dunn and Sean Walsh, who made available their large collections of Cape League photographs and memorabilia. Karen Gradowski of the Heritage Museums and Gardens tirelessly assisted me in my research. The art department at Bourne High School, in particular Ken Carson and his students Sarah Fuller, Sarah McRoberts, and Ashley Paulsen, filled in with illustrations where photographs were not available.

David Still, editor of the Barnstable Patriot; Frank Finn, publisher and editor of the Cape Cod Sports Report; Arnold Miller, photo editor of the Cape Cod Times; Dan Webb, photo editor of the Falmouth Enterprise; and Rich Eldred, of the Cape Codder, all assisted in putting this book together.

I also owe a debt of gratitude to managing editor Janice Walford and sports editor Rich Maclone of the Enterprise Newspapers for putting up with me as I obsessed over old baseball photographs.

Information from James H. Ellis's article "Cape Cod League a Talent Showcase," in the *Baseball Research Journal* (1986), and Christopher Price's *Baseball by the Beach* was crucial in the writing of this history.

Last, but most important, thanks go to my wife, Kathy, son Chris (who, like his dad, is a big baseball fan), and daughter Chelsea, whose patience, support, and understanding allowed me to complete this project.

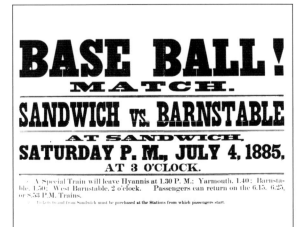

The modern-day Cape Cod Baseball League traces its origins to this 1885 broadside. However, there is equal evidence to suggest that the league in fact grew from the 1865 Nichols Club and teams that sprang up immediately following the American Civil War. It was not until 1923 that the loose organization of teams on the Cape joined to become the Cape Cod Baseball League. (Courtesy National Baseball Hall of Fame Library, Cooperstown, New York.)

INTRODUCTION

During the American Civil War, the popularity of baseball increased as soldiers in the North and South played it for recreation and as a diversion from the gory truth of battle. When the conflict ended, baseball clubs and organizations sprang up quickly across the country as the popularity of the sport was spread by soldiers returning home.

Baseball was known on Cape Cod before the war, but with the end of hostilities came the first organized club. In 1865, the Nichols Club of Sandwich was formed. The team drew its name from sea captain Edward Nichols, who generously offered his field on School Street as a site for the team to play.

The game grew quickly, with clubs in Cummaquid and Yarmouth forming and rivalries developing. By the 1880s, baseball was a regular sight from Bourne to Provincetown. The attraction of the Cape in the summer and good baseball had already begun to appeal to outside players. According to historian James H. Ellis, "the 1885 Barnstable team retained three starters from the Harvard College nine." Cape teams, in addition to playing against each other, faced teams from across southeastern Massachusetts, Boston, and Lowell. In 1883, Barnstable won the championship of southeastern Massachusetts, and Sandwich did the same in 1888.

With the arrival of the 20th century and the advent of the automobile, travel improved. Still, teams could spend more time getting from one end of the Cape to the other than it would take to play a game. But Cape fans loved the game, and a baseball match was an event that often included a picnic with family and friends, making it an all-day affair. In 1919, Framingham native Pie Traynor played shortstop for the Falmouth team. The next year, he was in the majors with the Pittsburgh Pirates, following a path so many more Cape players would travel.

Local teams continued to compete against each other as well as with outside teams. Local newspapers followed the action, printing the standings of the Cape squads in head-to-head competition. But the financing of a team was becoming a concern as some teams folded. On the threshold of the Roaring Twenties, Harry Albro of Falmouth, Arthur Ayer of Osterville, William Lovell of Hyannis, and J. Hubert Shepard of Chatham saw the time as right to establish a Cape League. As Ellis points out, a Cape League was "logical and desirable." It would create natural rivalries, increase fan support, and generate income, while saving travel costs. In 1923, the new league's first season, Chatham, Falmouth, Hyannis, and Osterville fielded teams with rosters that included many college players. Hyannis won the first two years, and it was not until 1927 that the league expanded, adding Wareham. In 1928, Chatham left, but a combined Chatham-Harwich team joined along with Orleans. Barnstable entered the league in 1932, and in 1933, Provincetown jumped in but lasted just half of the season, being replaced by Bourne.

On the eve of World War II, the Cape League staged its first night game, held at Falmouth Heights on July 19, 1939, in a contest between Falmouth and Barnstable. Falmouth won 13-4. The next night, they took their portable lights to Hyannis and the same two teams played again.

The rising tempest of war diverted attention from baseball. With the energy and resources of the nation focused on the brewing conflict, the Cape League disbanded after the 1939 season.

The end of the war and the return of the boys from military service brought with it the revival of baseball and a new Cape League in 1946. The new league was divided into upper and lower divisions, once again easing travel. This time, however, the new league stipulated that players must be Cape residents.

Once again, the crack of the bat could be heard across the peninsula. Like its predecessor, the new Cape League witnessed teams joining and withdrawing from the league as finances dictated. At times, teams from Massachusetts Maritime Academy, Otis Air Force Base, and the Cape Verdean Club of Harwich played in the league. The rules stipulating that players must be residents were gradually relaxed as more college players found their way onto the rosters. Teams from Sagamore and Orleans dominated the league throughout the 1950s until Yarmouth managed to win the championship in 1958. Cotuit challenged Yarmouth in 1961, taking the crown, but change was once again in the wind. The Cape League had evolved onto something more than was envisioned in 1923 or in 1946. By the early 1960s, rosters were dominated by college players. In the fall of 1962, Danny Silva, Arnold Mycock, and Bob McNeece, all principles in the Cape League, along with a representative of Major League Baseball, met to discuss the future of the league. The modern Cape Cod Baseball League, supported by Major League Baseball and operating under the guidelines of the National Collegiate Athletic Association, was the eventual result.

The year 1963 marked the beginning of the modern Cape Cod Baseball League, although it took some time for all the pieces to fall into place. There were no longer the same upper and lower leagues. Instead, the league was divided into lower (eastern) and upper (western) divisions. Bourne, Cotuit, Falmouth, Sagamore, and Wareham made up the upper division, while Chatham, Harwich, Orleans, Otis Air Force Base, and Yarmouth comprised the lower division. In 1975, Bourne withdrew from the league, opening the door for Hyannis the following year. In 1977, Yarmouth became Yarmouth-Dennis. In 1988, the league expanded to 10 teams with the addition of Bourne in the west and Brewster in the east.

Many major-league players spent a summer or more on the Cape. The Cape's own Danny MacFayden reached the majors in 1926 and coached baseball at Bowdoin College. Red Rolfe played for Orleans in 1930 and then went on to a major-league career before coaching at Yale and for the Detroit Tigers. Carlton Fisk (of the University of New Hampshire) played for Orleans in 1966 and, in shades of what was to come, hit a home run in his first Cape League at-bat. At the conclusion of the 2003 season, the Cape Cod Baseball League could boast of 190 active alumni in the major leagues and, with the minor leagues loaded with past Cape Leaguers, that number will quickly top 200.

Run by volunteers with baseball in their blood, the Cape League has built a reputation for some of the finest summer collegiate baseball in the country. Recently, the Cape League family lost two of its own—Fred Ebbett and Arnie Allen. In their memory and the memory of the countless others that have gone before, baseball on the Cape will move on and continue to be the premier summer collegiate league in the nation and a steppingstone to professional baseball.

One

TOWN BALL AND THE GROWTH OF THE GAME 1865–1922

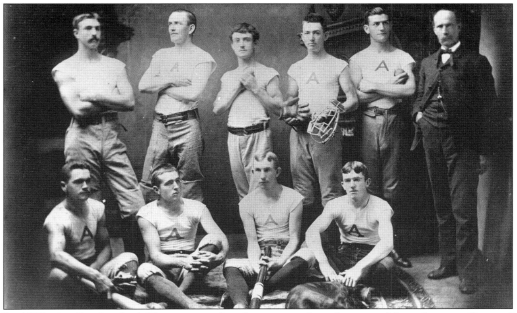

In 1888, the Sandwich Athletics were the champions of southeastern Massachusetts. Pictured here, from left to right, are the following: (front row) Eugene Haines, Augustus R. Pope, Charles Chamberlain, and Jimmy McCann; (back row) Ezra T. Pope Jr., Junie Dalton, Ed Kenney, Henry Dalton, George McNamee, and manager Ezra Hamlin. Ezra T. Pope Jr. went on to play professional baseball for Tacoma of the Pacific Coast League. (Courtesy Sandwich town archives.)

In the years following the Civil War, entertainment and transportation were limited, but baseball had grown to a passion locally. One winter during the 1870s, the Star and Active Ball Club of Sandwich cleared a diamond on the ice of Mill Pond opposite the old town burial ground and, wearing ice skates, proposed to play a game. No other teams could be induced to join them, forcing the Star and Active team members to compete among their own players. (Illustration by Sarah McRoberts.)

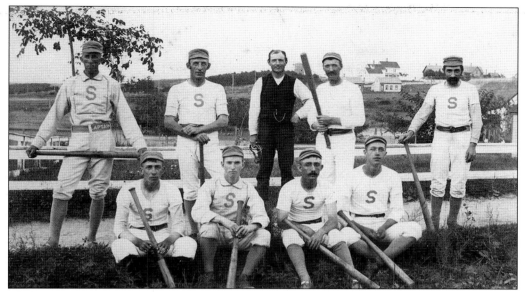

The game was popular enough that businesses on the Cape sponsored teams. These company teams would play against club and town teams with players sometimes playing for more than one team. The photograph above is of the 1890 Orleans Pants Factory team. (Courtesy Orleans Historical Society.)

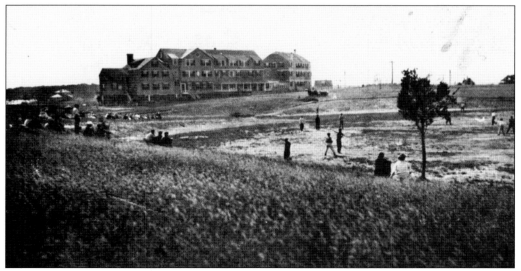

As the 20th century approached, most towns on the Cape had teams that would play against one another as well as against teams from neighboring southeastern Massachusetts. This photograph depicts a game in Osterville near the turn of the century. (Courtesy Barnstable Patriot.)

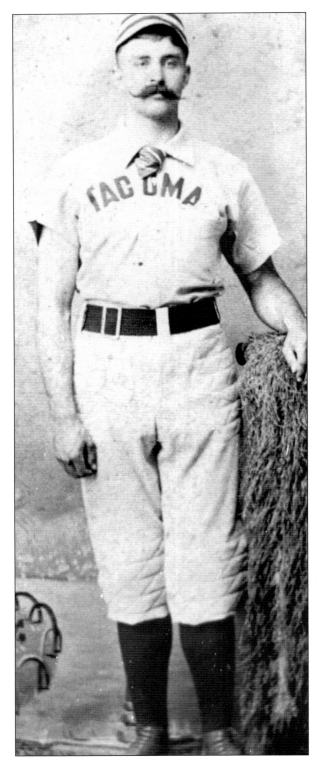

Ezra T. Pope Jr., a member of the southeastern Massachusetts championship Sandwich Athletics in 1888, went on to play professionally for the Tacoma team of the Pacific Coast League in 1890. (Courtesy Sandwich town archives.)

At times, uniforms consisted of whatever a player could find, and equipment was owned individually. In this 1893 Craigville team photograph, the player to the far right is an American Indian, probably Wampanoag. (Courtesy Marion R. Vuilleumier from her book *Craigville on Old Cape Cod*.)

Sometimes travel to the game would take longer than the game itself. Teams traveling from Sandwich and Falmouth to Orleans and Chatham took a buckboard or horse barge with family and friends going along for the day. After the game, it was not unusual for teams to picnic before beginning the long trip home. (Illustration by Ashley Paulsen.)

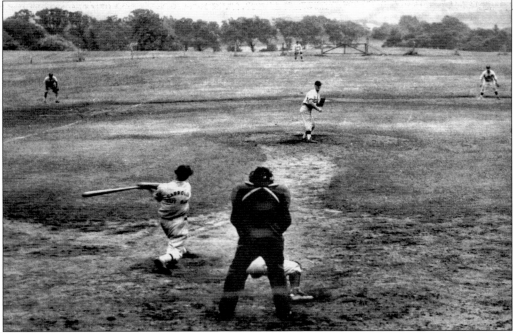

The Casino Field on School Street in Sandwich was one of the first baseball fields on the Cape. (Courtesy Sandwich town archives.)

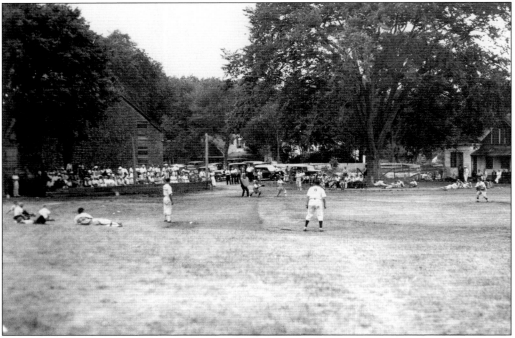

Seen here is a later view of the Casino Field in Sandwich with buildings and automobiles. The Casino (not pictured) was an all-purpose building erected in 1884 for social events. The field was used for baseball into the 1940s. (Courtesy Sandwich town archives.)

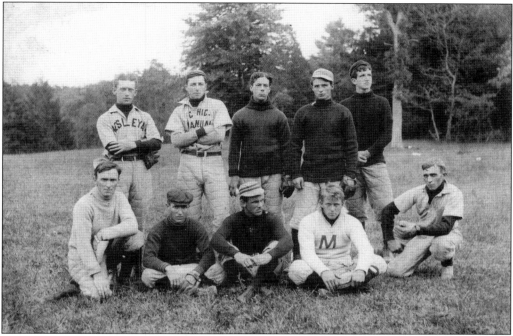

This 1904 Harwich team, put together for a homecoming weekend, reflects the early influence of college players on the Cape, as seen by the uniforms. (Courtesy Harwich Historical Society.)

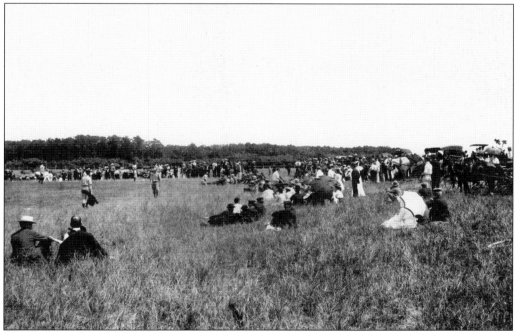

This game, held in South Harwich in 1904, was a part of the homecoming weekend. (Courtesy Harwich Historical Society.)

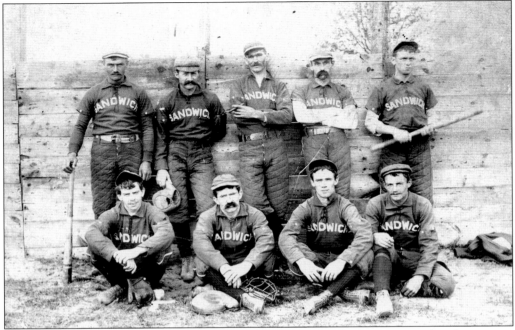

This Sandwich team from the turn of the century is wearing quilted pants, introduced to protect the player and withstand the wear of sliding, but they were undoubtedly hot in the summertime. Their long-sleeve jerseys could be unbuttoned to create short sleeves on hot days. (Courtesy Sandwich town archives.)

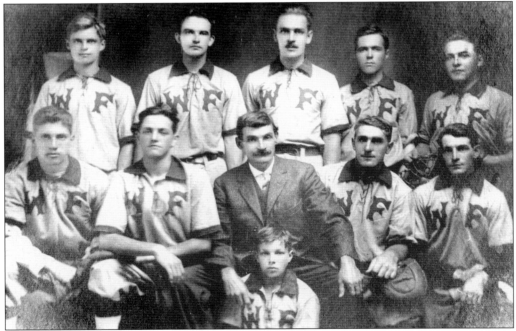

It was not unusual for many of the villages on the Cape to have teams. This is a team from West Falmouth from near the turn of the century. (Courtesy Falmouth Enterprise.)

16

This 1909 Sandwich team was the Barnstable County champion. The figure in the middle is the team manager. Seldom did teams have more than nine players, leaving little room for absence or injury. (Courtesy Sandwich town archives.)

This Chatham team from 1908 reflects a mixture of town, company, and high school uniforms. It was not unusual for local players from different teams to join together for a game. (Courtesy Chatham Historical Society.)

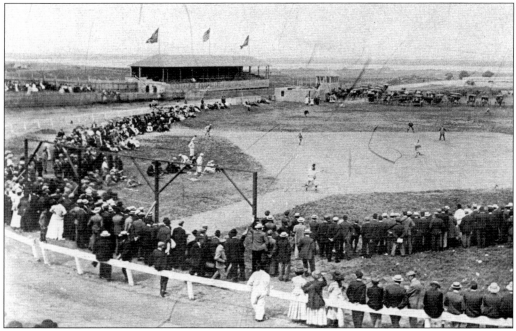

The Barnstable fairgrounds along Route 6A just east of the village of Barnstable was home to horse racing and baseball. In this 1910 photograph, a game is taking place on the infield of the racetrack. (Courtesy Cape Cod Community College Nickerson Room.)

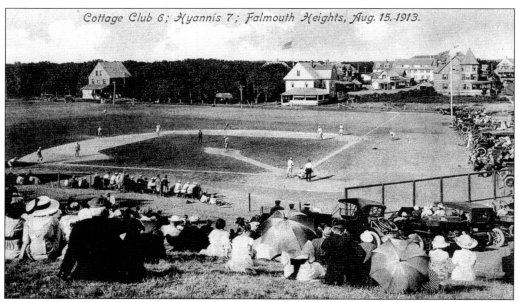

Cottage Club 6; Hyannis 7; Falmouth Heights, Aug. 15. 1913.

Right field at Falmouth Heights was so short that the outfielder was forced to play back against the fence. The house just beyond the fence was close enough to be within range of the hitter and was usually screened by netting during a game. (Courtesy Dan Dunn Collectables.)

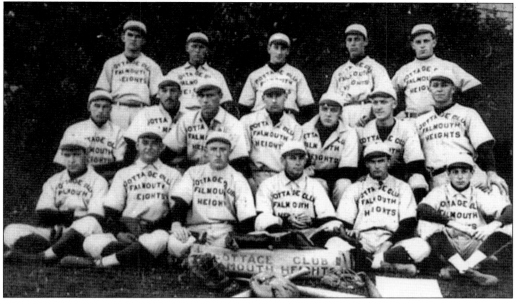

The Cottage Club of Falmouth Heights was one of the stronger teams in the early years of the 20th century. Pictured here in 1913, the club included local as well as college players. (Courtesy Falmouth Enterprise.)

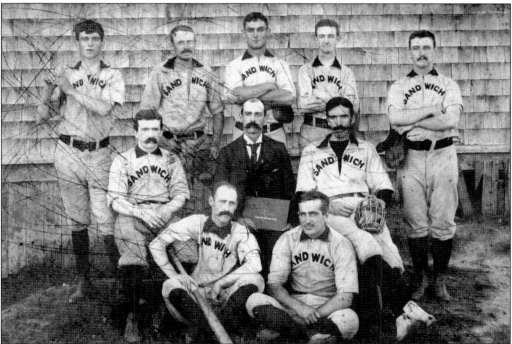

This turn-of-the-century Sandwich team had just nine players. Note the catcher's mask held by the player in the middle row. The mask, first worn by players in 1877, initially received mixed reviews, as some felt it was unnecessary. By 1890, catchers were using padded gloves. (Courtesy Sandwich town archives.)

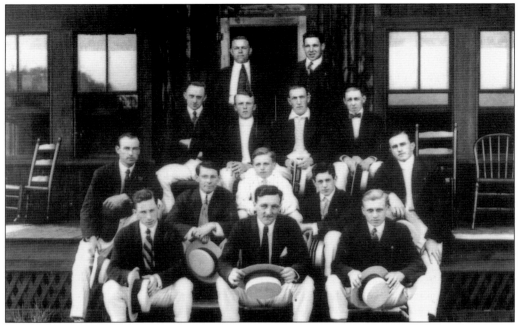

Ballplayers from the Falmouth Cottage Club team pose in 1915 in this team portrait. (Courtesy Falmouth Enterprise.)

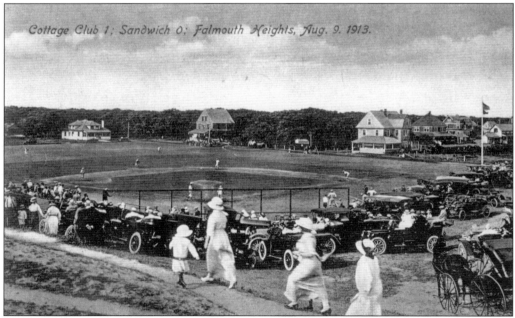

Cottage Club 1; Sandwich 0; Falmouth Heights, Aug. 9. 1913.

Early in the 20th century, attending a ballgame on the weekend was a dressy affair. Ladies wore their Sunday best, and gentlemen came in jackets and ties. Fans could watch from their cars, but there was always the danger of being hit by a foul ball. (Courtesy Falmouth Historical Society.)

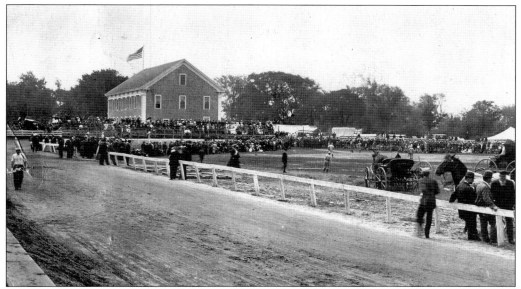

This is a game at the Barnstable fairgrounds along Route 6A on the infield of the racetrack early in the 20th century. Fans then, as they do today, were able to sit along the edge of the playing field to watch the game. (Courtesy Dan Dunn Collectables.)

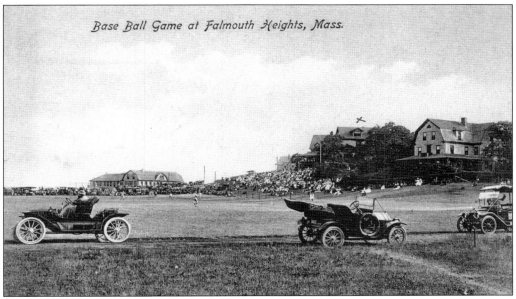

Base Ball Game at Falmouth Heights, Mass.

The automobiles in the foreground of this 1914 photograph taken at Falmouth Heights are parked in deep left field. The casino is the large building on the water just behind the field. (Courtesy Dan Dunn Collectables.)

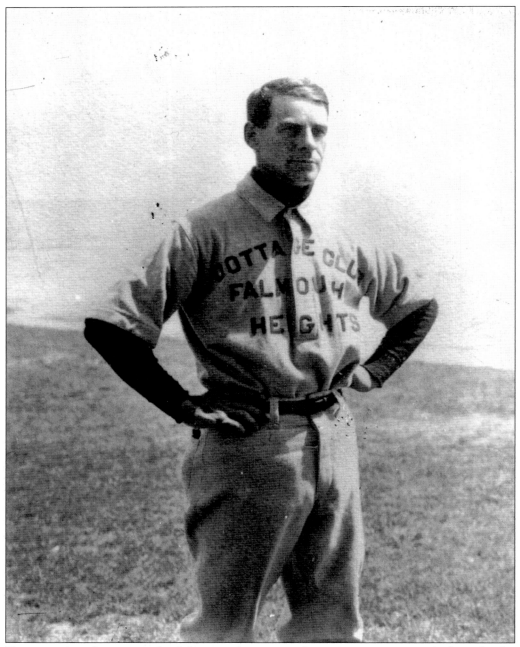

Heavy wool uniforms were the fashion, and jersey numbers were yet to come. A player for the Cottage Club of Falmouth, as seen in this 1915 photograph, might have been a local, college, or semiprofessional player. (Courtesy Falmouth Enterprise.)

Clubs from the Cape would travel by train to play as far away as Fall River, Boston, or Lowell. Sometimes, the trip would include staying away from home overnight as they would play several games during the trip. On one such occasion, because funds were short, a Sandwich team of 13 shared a single hotel room and a single bed for the night. (Illustration by Sarah Fuller.)

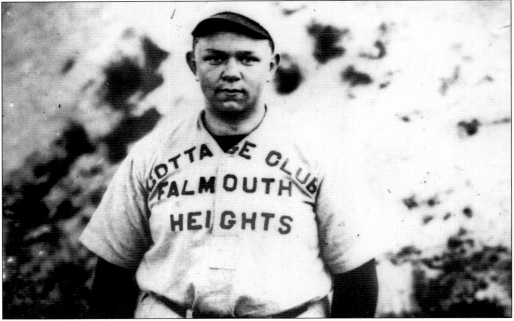

Ballplayers then, as now, were given added attention. Here, a member of the 1915 Cottage Club team poses for a photograph. (Courtesy Falmouth Enterprise.)

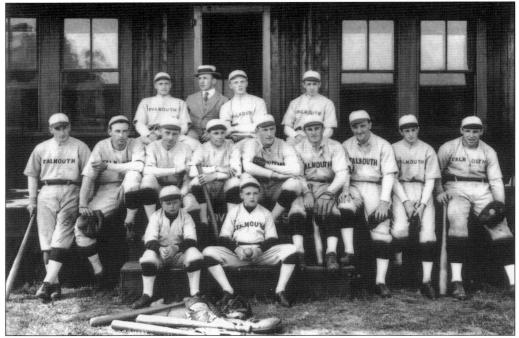

The Falmouth Cottage Club team was well equipped. Among the bats and gloves at the feet of the bat boys is a pair of catcher's shin guards. The protective guards were introduced in 1906 and made popular the next year by New York Giants catcher Roger Bresnahan. (Courtesy Falmouth Enterprise.)

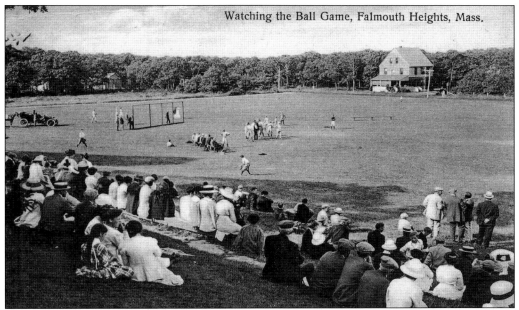

Watching the Ball Game, Falmouth Heights, Mass.

The Central Park field at Falmouth Heights was one of the more popular spots for baseball on the Upper Cape during the first half of the 20th century and always drew a big crowd. (Courtesy Dan Dunn Collectables.)

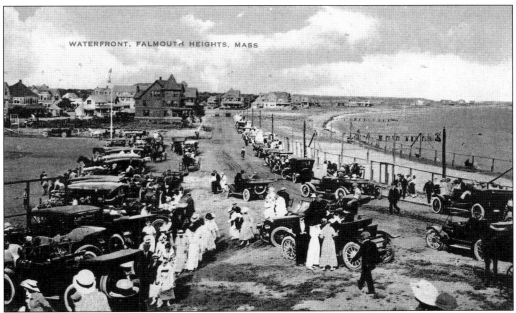

WATERFRONT, FALMOUTH HEIGHTS, MASS

Baseball was one of the few forms of entertainment early in the 20th century that allowed fans to gather, socialize, catch up on the news, and visit with friends. On the beach across from the field, a wooden deck has been placed over the sand to allow Cottage Club members and guests to play tennis. (Courtesy Dan Dunn Collectables.)

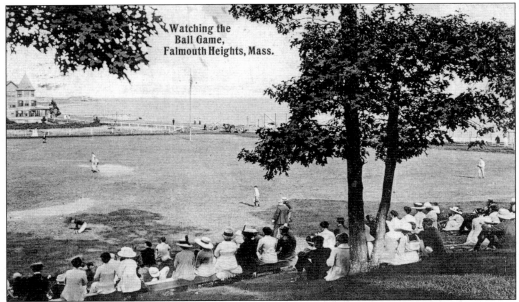

Sitting in the shade on the hillside at Falmouth Heights, fans could pass an enjoyable afternoon with friends. Vineyard Sound was just to the right, providing cool breezes on summer afternoons. (Courtesy Dan Dunn Collectables.)

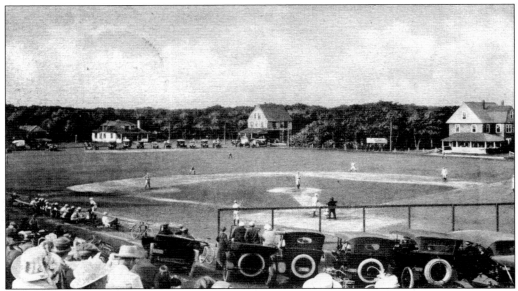

The game was growing in popularity on the Cape as the country entered the Roaring Twenties. Ballplayers remained mostly local, but rosters almost always included college players, most from New England schools. (Courtesy Dan Dunn Collectables.)

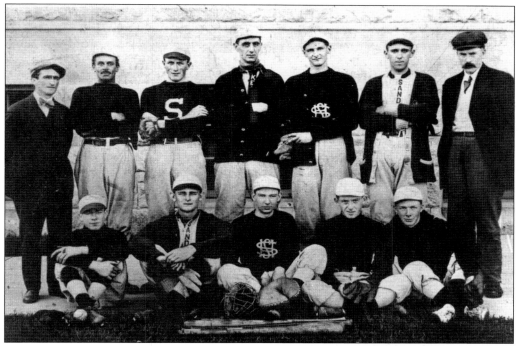

On Cape Cod, baseball continued to grow right up to the opening of World War I. This 1916 Sandwich team was no doubt well aware of the growing European conflict, and members of the team may well have served with American forces abroad. (Courtesy Sandwich town archives.)

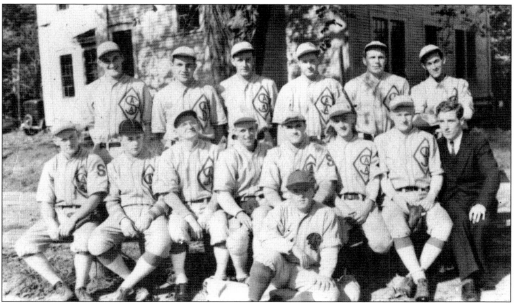

This Sandwich Athletic Association squad probably took the field in the early 1920s, while town teams still made up most of the competition on the Cape. (Courtesy Sandwich town archives.)

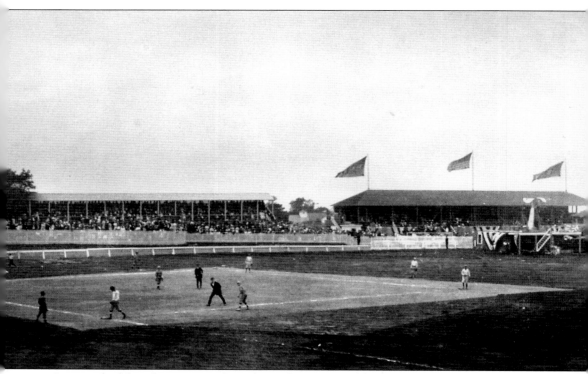

America had found new strength in the early 1920s, and baseball was America's game. In this 1921 photograph, fans pack the grandstand at the Barnstable fairgrounds along Route 6A to watch a game on the infield of the racetrack. The game had reached such a level of popularity locally that within two years the first organization to use the name Cape League was formed. (Courtesy Trayser Museum.)

Two

THE EARLY CAPE LEAGUE
1923–1939

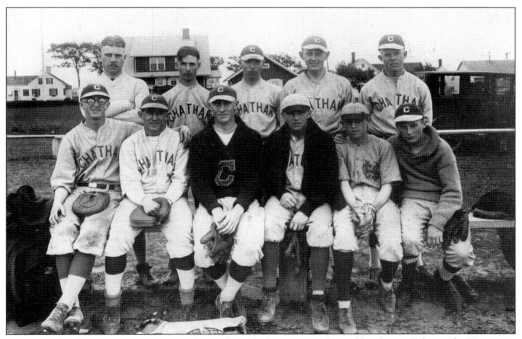

In 1923, the first Cape League was formed, including teams from Chatham, Falmouth, Hyannis, and Osterville. William Lovell of Hyannis was the first Cape League president. Above is the 1924 Chatham team. Teams at the time were composed of locals, including some high school stars, along with college and semiprofessional players. Other Cape towns continued to field teams but did not belong to the new Cape League. (Courtesy Chatham Historical Society.)

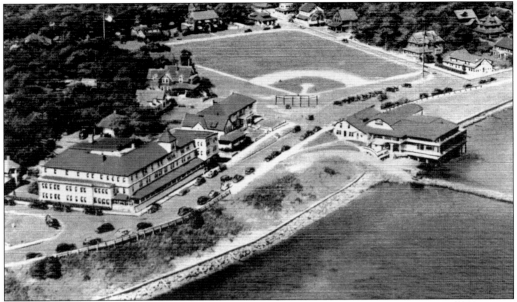

This postcard provides an overhead view of the baseball field at Falmouth Heights in the early 1920s. The Central Park field was home to the Falmouth team until 1964, when the team moved to Guv Fuller Field. (Courtesy Dan Dunn Collectables.)

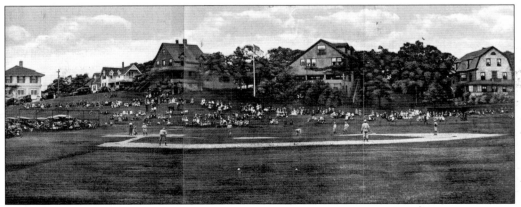

This is a scene from Falmouth Heights in 1923. Cape League teams played teams from off the Cape as well. Teams from as far away as Boston, Attleboro, and New Bedford were regular opponents. However, it was only the games played against one another that were reflected in the Cape League standings published in the local newspapers. (Courtesy Dan Dunn Collectables.)

Members of the 1924 Falmouth team pose with their manager at Falmouth Heights. The ninth player is on the left, out of the frame. Martha's Vineyard sound is behind the line of automobiles. (Courtesy Al Irish.)

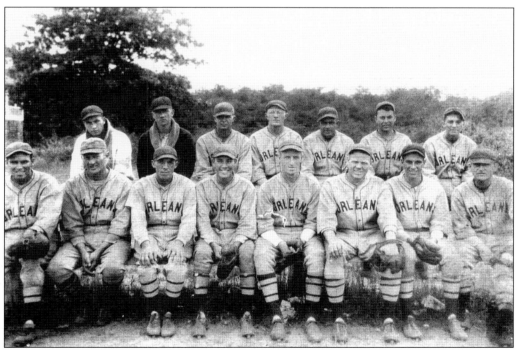

Many villages on the Cape had a team in the 1920s, but money was always a problem, with teams playing one year and gone the next. By 1923, the league had gained some stability. Orleans did not join the new Cape League until 1928. (Courtesy Orleans Historical Society.)

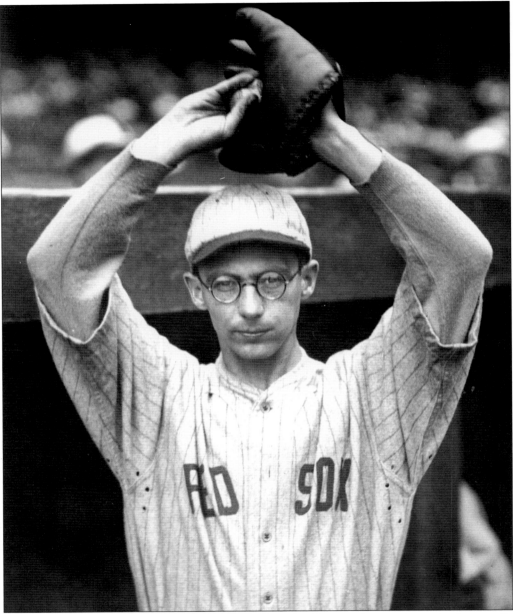

Three players who were born and played baseball on the Cape made it to the major leagues. In addition to Ed Conley, there were Joel Sherman of Yarmouth, who pitched in two games for the 1915 Philadelphia Athletics, and Danny MacFayden from North Truro. MacFayden played for Osterville in 1924 and Falmouth in 1925 and pitched one game for Osterville in 1926. He joined the Boston Red Sox late in 1926 and went on to have a 17-year major-league career. (Courtesy National Baseball Hall of Fame Library, Cooperstown, New York.)

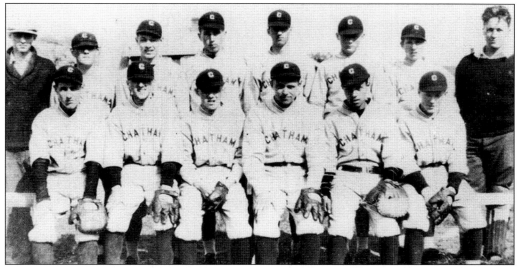

This 1927 Chatham team combined with Harwich in 1928–1929. In 1930, Chatham once again fielded a team in the Cape League, but it lasted just two seasons. It was not until after World War II that Chatham once again joined the league. Harwich remained active until the league disbanded after the 1939 season. While there was no Cape League from 1940 to 1945 because of the war, there was still baseball, as towns continued to field teams. (Courtesy Chatham Historical Society.)

Towns from Wareham to Provincetown fielded teams in the years leading up to World War II. North Truro had a team but never participated in the league. The team played some of their games near Highland Light. The lighthouse stood in the center-field background. (Illustration by Sarah McRoberts.)

Wareham had its own league, with different villages raising their own teams. Above is a team from the Tremont section of Wareham that played in the mid-1920s. (Courtesy Dotty Tamagini.)

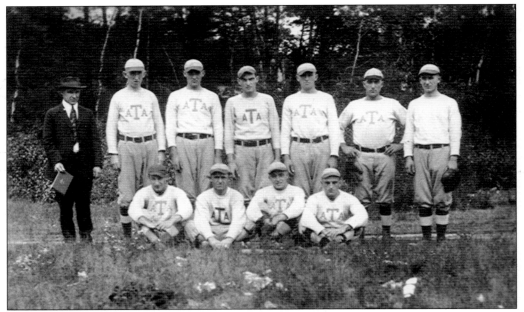

In this photograph of the same Tremont team are, from left to right, the following: (front row) Benny Dustin (center fielder), Eino Balboni (pitcher), Guy Maloni (left fielder), and Joe Alberghini (second baseman); (back row) business manager Fred Hepburn, team manager Bill Butler, Jerry Maloni (right fielder), Eddie Tamagini (catcher), Barstow Maloni (third baseman), Alfred Pappi (short stop), and Medeo Pedzarzani (first baseman). (Courtesy Dotty Tamagini.)

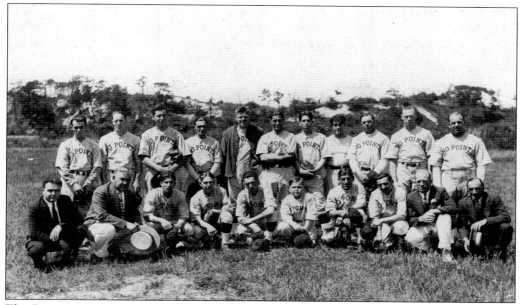

The Provincetown Longpointers joined the league in 1933 with a roster of local players. In addition to playing against Cape League opponents, the Longpointers took on teams from the Greater Boston leagues who would take the boat across Cape Cod Bay for a game. They also faced traveling teams that arrived on the Cape in the 1930s, such as the House of David and the New York Clowns. The team played at Evans Field and that year posted a record of 18-4. (Courtesy Hersey Taylor Jr.)

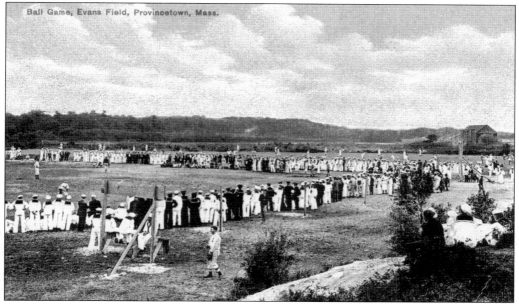

The U.S. Navy had a large presence in Provincetown in the years leading up to World War II. Sailors were always on hand in numbers to watch a ballgame at Evans Field. While the military teams were not a part of the Cape League, Provincetown was a popular spot for baseball in the years leading up to the war. (Courtesy Dan Dunn Collectables.)

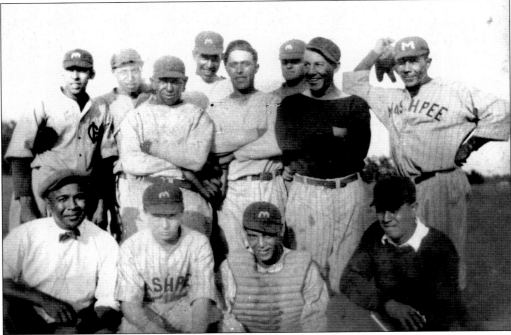

Mashpee always fielded good teams, but they were not a part of the Cape League until after the war. This team from the 1930s would have played at the town's Twelve Acres Field, which overlooked the foot of Mashpee-Wakeby Pond. One of the star players for the all-Indian team was Jeff Hicks, who contemporaries believed could have played in the major leagues. (Courtesy Donald Hicks.)

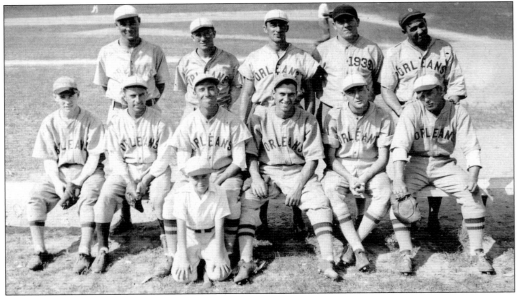

Orleans joined the Cape League in 1928 with most of their roster comprised of college players. The bat boy in this photograph of the 1933 team is Bobby Long of Orleans. (Courtesy Roy Bruninghaus.)

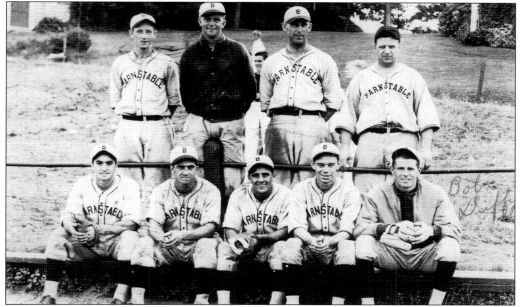

The player seated to the left in this photograph of the 1933 Barnstable team is Lennie Merullo, who went on to play for seven years for the Chicago Cubs before becoming a major-league scout. Three generations of the Merullo family played in the Cape League, including his grandson Matt, who played for Harwich in 1984 before moving on to a six-year big-league career with the White Sox and Twins. (Courtesy Roy Bruninghaus.)

This team from the mid-1930s, possibly an early all-star squad, is made up of players from several teams, including Barnstable, Hyannis, and Osterville. Barnstable fielded strong teams in the mid-1930s, winning the championship in 1934 and 1937 as well as winning the first half of the season in 1935. (Courtesy Chris Rogers.)

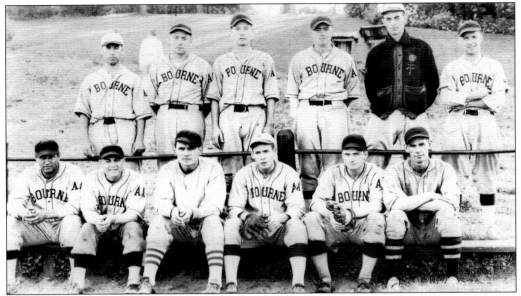

This 1934 Bourne team was the first to play a full season in the Cape League. When Provincetown left the league midway through the 1933 season, Bourne stepped in and remained in the league until it halted play in 1939. (Courtesy Roy Bruninghaus.)

Keith Field in Sagamore was opened in 1935 on land formerly owned by the Keith Car Company. There was no outfield fence at the time. Instead, the grass was allowed to grow around the perimeter of the outfield. The grass was so tall that a ball hit into it was often not found. The field grew into one of the hot spots for baseball in the Upper Cape. (Illustration by Ashley Paulsen.)

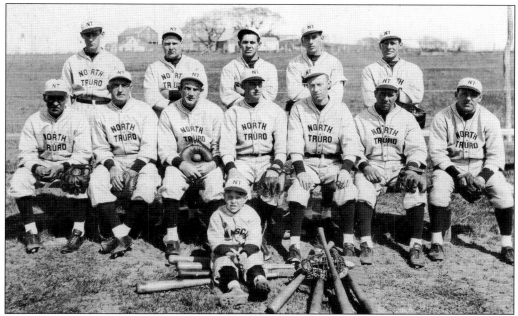

This 1937 North Truro team was not a member of the Cape League but faced many of the teams that played on the Cape. Most towns on the Lower Cape had teams, including Provincetown, Wellfleet, and Eastham. When North Truro played a member of the Cape League, the results did not affect the Cape League standings. (Courtesy Truro Historical Society.)

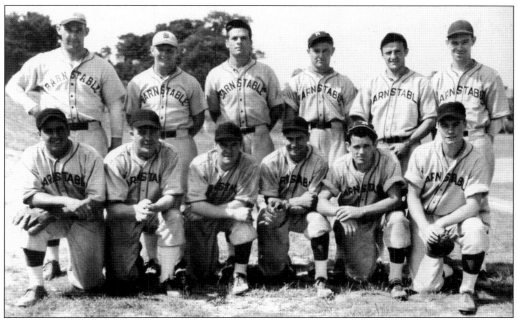

This 1937 Barnstable team won the Cape League championship on the final day of the season with a 5-0 victory over Bourne. Norman Merrill pitched a no-hitter for Barnstable to give his team a league-leading 29-17 record that year. (Courtesy Trayser Museum.)

In 1938, Bill Butler managed the Tremont team in Wareham. Butler was active in Wareham baseball throughout the 1920s and 1930s right up to the outbreak of World War II. (Courtesy John Savastano.)

Pete Savastano was a member of the 1938 Wareham Tremont team. Two years later, many of the teams on the Cape would cease to exist, as the war drew many of the players into the military service. (Courtesy John Savastano.)

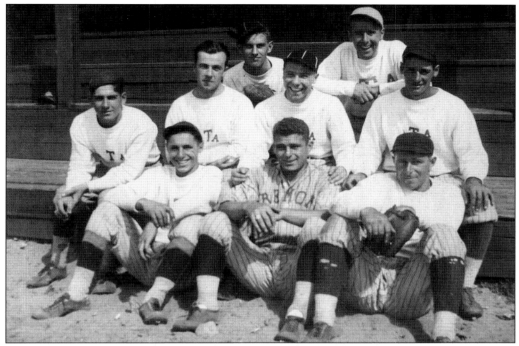

Ballplayers, then as now, often gave one another nicknames. Seen here are, from left to right, the following: (front row) Tony "Bones" Gallerani, Fred "Plu" Ferioli, and Elwin "Vino" Lodi; (middle row) Albert "Pete" Rondelli, Elmo "Bal" Balboni, John "Savvy" Savastano, and Victor "Babe" Gallerani; (back row) Casmar "Mac" Krystofolski and Mario "Mussey" Bonzanni. Within two years of this 1938 photograph, most of the players were in the military. (Courtesy John Savastano.)

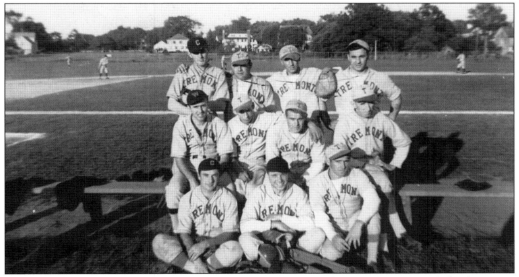

Wareham was in the Cape League from 1927 to 1928 and 1930 to 1932. While this 1938 Wareham team sponsored by the Tremont Athletic Association was not officially in the league, they did face Cape League clubs as well as teams from across the area. (Courtesy John Savastano.)

With the new Keith Field as a home, Sagamore fielded a team in the late 1930s. After the war, Sagamore became one of the stronger clubs in the league. (Courtesy Tello Tontini.)

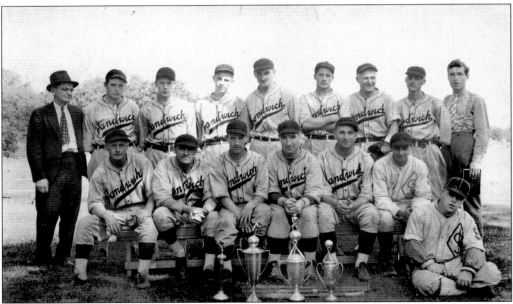

Home to the birth of the organized game on the Cape, Sandwich never joined the original Cape League. The town, however, continued to field teams that played across the area. This successful team from the late 1930s faced teams from the Cape as well as from across the bridge. (Courtesy Phil Ellis.)

Three

THE UPPER AND LOWER CAPE LEAGUE YEARS 1940–1962

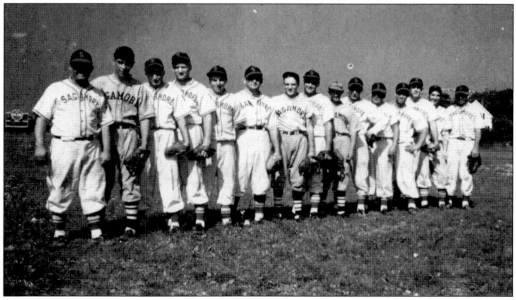

The Cape League was inactive during the war years, from 1940 to 1945. However, once hostilities ended, the boys were back on the diamonds of the Cape, initially with players who were all Cape natives. The league was divided into Upper and Lower Cape squads with new teams joining the league. The Sagamore Clouters, pictured in this 1947 photograph, became one of the more successful teams of the 1950s. (Courtesy Tello Tontini.)

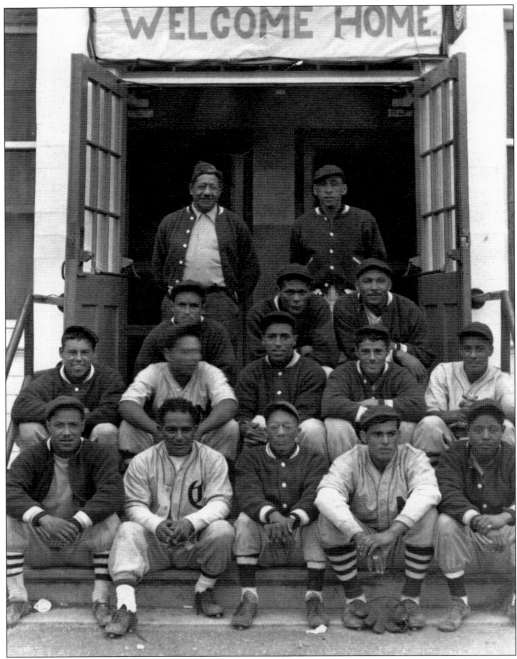

The 1946 Mashpee team rests on the steps of the United Service Organizations (USO) building that once stood on Route 130. The sign over the door spells out what everyone was feeling as the postwar Cape League got down to business. Teams moved in and out of the league throughout the early years, with each season reflecting different lineups. The country was getting back to normal, and baseball, with its roots in American tradition, provided fun entertainment and the chance to visit with friends. (Courtesy Donald Hicks.)

The fields of the Cape have always been fan-friendly. In 1947, when this photograph of the Mashpee team bench was taken, fans, friends, and admirers could watch a game from the perspective of the players. (Courtesy Donald Hicks.)

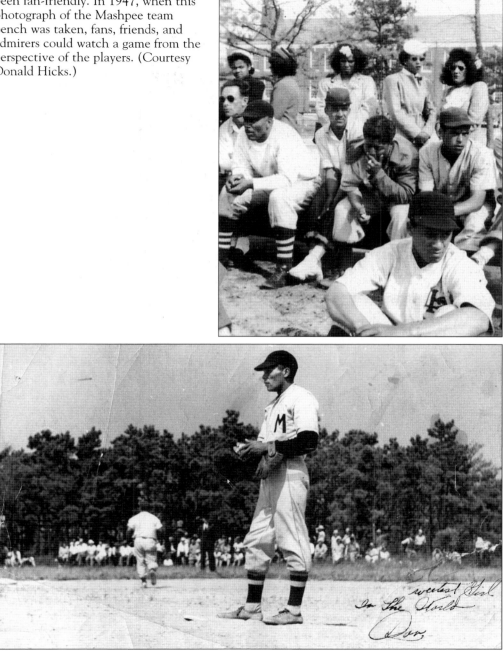

Mashpee pitcher Donald Hicks, according to the men who faced him, was one of the best hurlers to set foot on a Cape League mound. He helped take the 1948 Mashpee team to the league championship and won the league MVP award in 1950. Hicks had a blazing fastball, a good curve, and a change-up that froze hitters. When the Mashpee team withdrew from the league in the mid-1950s, he joined Cotuit. (Courtesy Donald Hicks.)

As a boy, Jim Perkins played baseball in the cotton fields of South Carolina. His prodigious hitting soon made a mark in the Cape League. Perkins hit two grand slams in the same inning for Cotuit on opening day, May 15, 1949, to defeat Sandwich 21-6. He is also known to have once hit a ball into the Cape Cod Canal from Keith Field, over 400 feet away. (Courtesy Jim Perkins.)

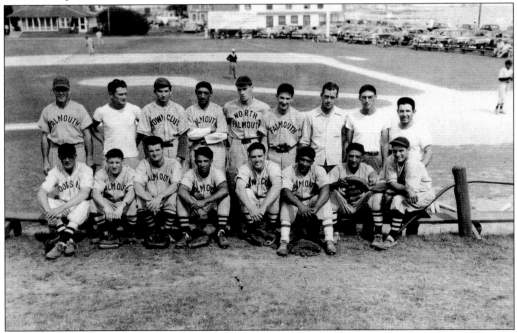

In the late 1940s, teams continued to move in and out of the league. On occasion, a town's entry in the Cape League would draw on other town teams to fill out a lineup, as noted by the different uniforms. Shown here, the Central Park field at Falmouth Heights hosted the first night baseball game on the Cape on July 19, 1939. (Courtesy Dan Dunn Collectables.)

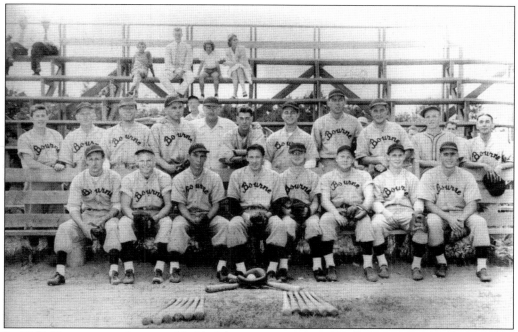

In 1947, Bourne won the second half of the season, earning the chance to face Mashpee in the Upper Cape playoff. The three-game series fell to Mashpee 2-1, but the Upper Cape champs came out on the losing side of the all-Cape series, dropping two straight to Orleans. At the time, Bourne played their games on the field behind the Jonathan Bourne Library. (Courtesy Don Cunningham.)

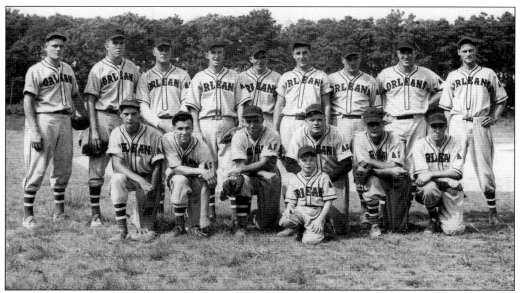

After winning the all-Cape championship in 1947, Orleans went to the National Baseball Congress Tournament in Wichita, Kansas, where they finished seventh. The team was managed by Herb Fuller. His 10-year-old son, Kenny, was the bat boy. (Courtesy Roy Bruninghaus.)

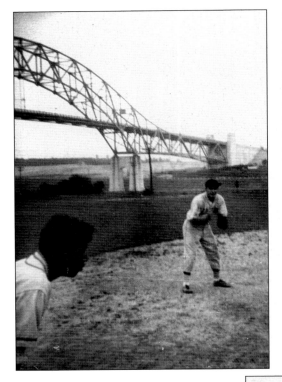

The Sagamore Bridge, built in 1935, is only 12 years old in this photograph, taken at Keith Field. Infielder Tello Tontini and the Sagamore Clouters battled Mashpee in the late 1940s for the Upper Cape crown. By the early 1950s, Sagamore was often at the top, squaring off against Lower Cape powerhouse Orleans. Tontini was an all-star shortstop for the Clouters and is considered one of the better players to have played on the Cape. (Courtesy Tello Tontini.)

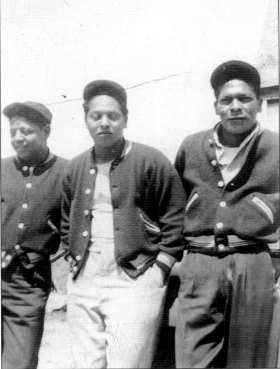

Mashpee fielded strong teams in the years following World War II. Doug Pochnett (left), brother Ollie Pochnett (center), and team ace Don Hicks (right) were just three of the reasons for their success. Doug Pochnett came at hitters from the left side, while Hicks was a hard-throwing right-hander. (Courtesy Donald Hicks.)

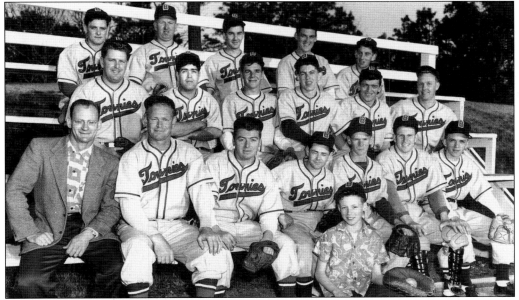

In 1949, Barnstable fielded a team in the Upper Cape League in addition to having a five-team twilight league. The rules were loosening up concerning the necessity that all players be from the Cape. By the 1950s, clubs began to add college players as the competition grew. (Courtesy Sean Walsh.)

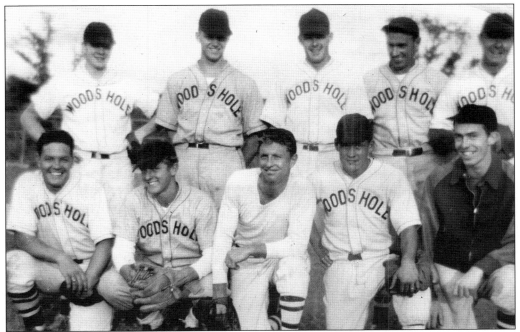

Other Cape towns established twilight leagues as the popularity of the game increased locally. Woods Hole, a part of Falmouth, fielded a team in the early 1950s. Players from the town leagues were always on the lookout for a spot on a Cape League team roster. (Courtesy Dan Dunn Collectables.)

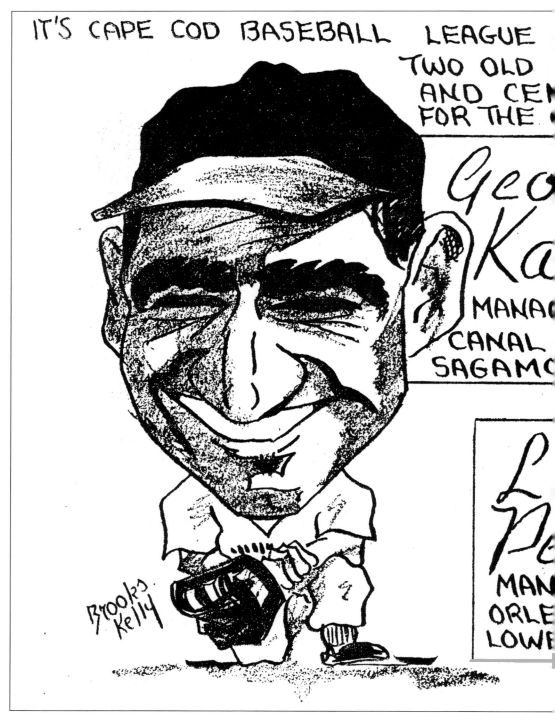

IT'S CAPE COD BASEBALL LEAGUE

TWO OLD
AND CEN
FOR THE

Geo
Ka
MANA
CANAL
SAGAMO

L
Pe
MAN
ORLE
LOWE

Brooks
Kelly

In 1952, the Canal Clouters of Sagamore and the Red Sox of Orleans faced each other for the all-Cape championship. Sagamore won both halves of the Upper Cape season while Orleans continued to dominate the Lower Cape division. The same two teams had faced each other in

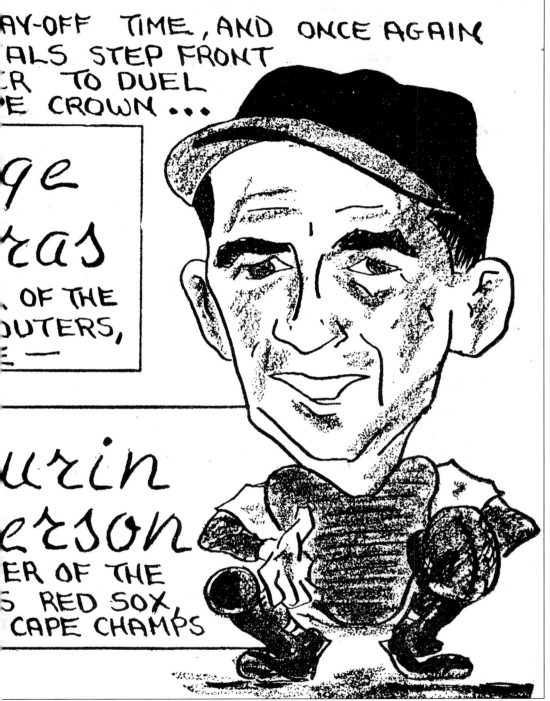

AY-OFF TIME, AND ONCE AGAIN
ALS STEP FRONT
R TO DUEL
E CROWN...

ge
ras

OF THE
UTERS,

urin
erson

ER OF THE
S RED SOX,
CAPE CHAMPS

1950 and again in 1951. Orleans took the crown in 1950, with the Clouters winning in 1951. The Red Sox came back to reclaim the crown with a win in 1952. (Courtesy Tello Tontini.)

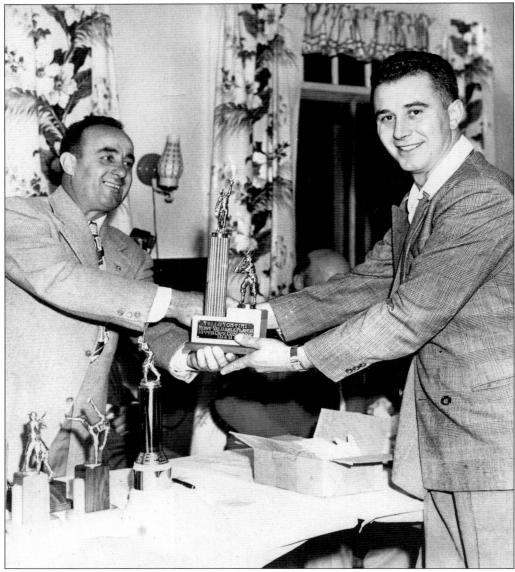

Upper Cape League commissioner Pat Sorenti presents the 1949 MVP award to Tello Tontini, who batted .403 that year. Tontini won the batting crown the next year and was the MVP again in 1951. In 1952, he led the Upper Cape League in hitting with a .398 average. (Courtesy Tello Tontini.)

Tello Tontini played short stop and third base for Sagamore. However, he began his career as a catcher. His teammate Jack Sanford was the winning pitcher in all three all-Cape championship games in 1951 and was the league's MVP in 1952. Together with a strong Clouter lineup, they dominated the Upper Cape League in the early 1950s. (Courtesy Tello Tontini.)

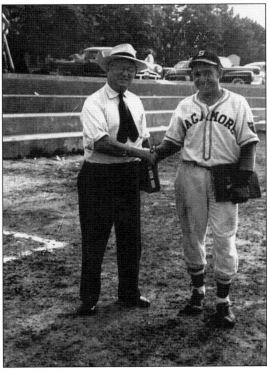

Bill Lane, shown here in the shirt and tie, was the manager of the Sagamore team until George Karras, who played for Lane, took over in the early 1950s. Karras went on to become the president of the Upper Cape League. (Courtesy Tello Tontini.)

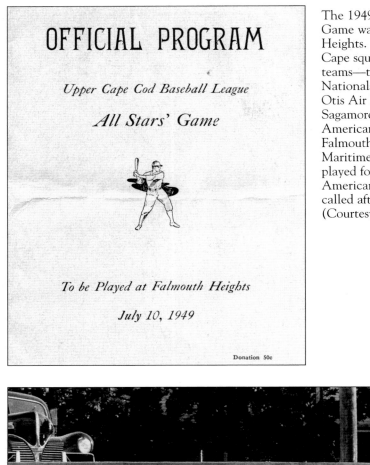

OFFICIAL PROGRAM

Upper Cape Cod Baseball League

All Stars' Game

To be Played at Falmouth Heights

July 10, 1949

Donation 50c

The 1949 Upper Cape All-Star Game was held at Falmouth Heights. Players from the Upper Cape squads were divided into two teams—the Americans and the Nationals. Barnstable, Sandwich, Otis Air Force Base, Mashpee, and Sagamore played for the Americans, while Bourne, Falmouth, Cotuit, Massachusetts Maritime Academy, and Osterville played for the Nationals. The Americans won 5-3 in a game called after five innings due to rain. (Courtesy Dan Dunn Collectables.)

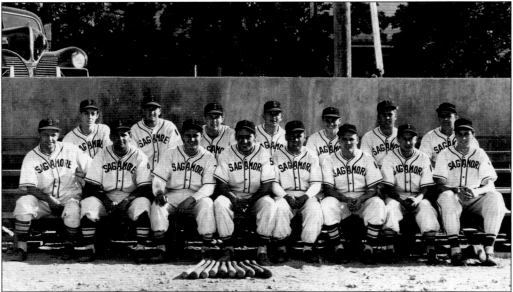

In this Sagamore team photograph from the late 1940s, taken at Keith Field, seated on the far right is Joe Allietta. He played for the Clouters and the Falmouth All-Stars and coached the baseball team at Falmouth High School. Both of his sons later played in the Cape League and were drafted by major-league clubs. Tontini is seated third from the left. The automobile in the background is a 1939 Dodge. (Courtesy Tello Tontini.)

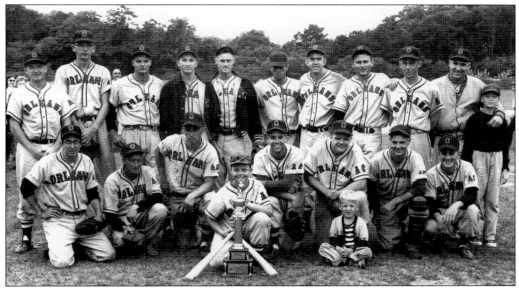

In 1954, the Orleans Red Sox won the Lower Cape championship and faced Sagamore for the all-Cape crown. The Clouters, however, won the best three out of five series. Pitcher Roy Bruninghaus, one of the reasons that Orleans was always at or near the top in the Lower Cape division, is pictured here with his arm around his 12-year-old son, Roy. The bat boy, Kenny Peterson, is posed behind the trophy with five-year-old Ron Bruninghaus to his left. (Courtesy Roy Bruninghaus.)

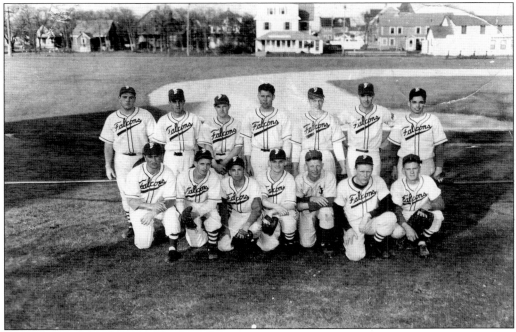

The Falmouth Falcons were a town team that played in the early 1950s. The uniforms were supplied by Eastman's Hardware. The Falcons played against squads from the Cape League and other town teams. (Courtesy Dan Dunn Collectables.)

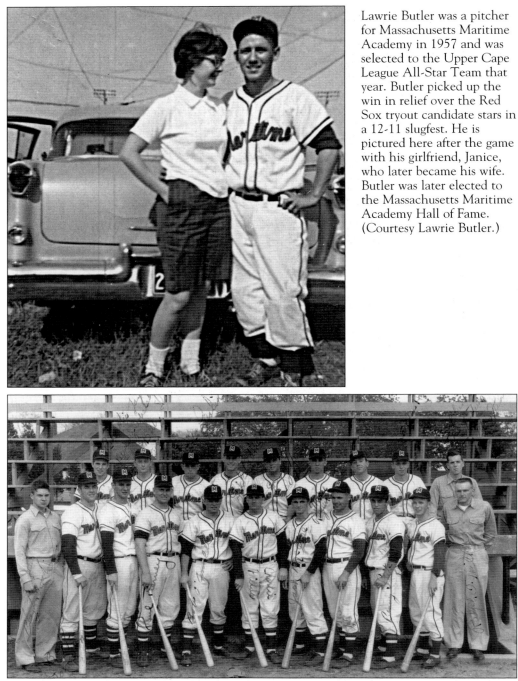

Lawrie Butler was a pitcher for Massachusetts Maritime Academy in 1957 and was selected to the Upper Cape League All-Star Team that year. Butler picked up the win in relief over the Red Sox tryout candidate stars in a 12-11 slugfest. He is pictured here after the game with his girlfriend, Janice, who later became his wife. Butler was later elected to the Massachusetts Maritime Academy Hall of Fame. (Courtesy Lawrie Butler.)

Massachusetts Maritime Academy was a member of the Upper Cape League during the 1950s. This 1957 team finished the season fifth, out of a field of six teams, with a record of 10-20. That year, the squad sent three players to the All-Star Game. In addition to Butler, there was catcher Paul Tierney and first baseman Bill Hendy. The academy later named their baseball field after Hendy. (Courtesy Lawrie Butler.)

Bill "Moose" Skowron (left) and Phil Rizzuto, both of the New York Yankees, present Sagamore's Bill Powers with the 1959 Ballentine Award as the Upper Cape League's most valuable pitcher. Powers also won the award in 1958. In 1959, he tossed a no-hitter and had a 12-strikeout performance against Barnstable, finishing the season with a record of 8-1. The Clouters lost the championship series in 1958 to Yarmouth but won it all in 1959. (Courtesy Dudley Jensen.)

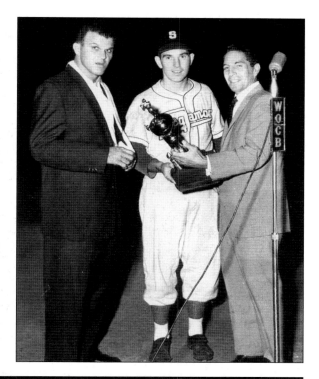

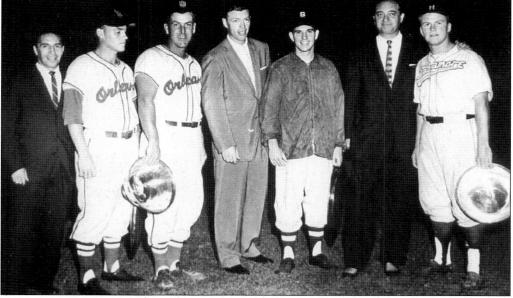

These Cape Leaguers were recognized for their accomplishments in 1959. Art Quick of Orleans received the Lower Cape's most valuable pitcher award, while teammate Stan Wilcox was selected as the most valuable player. Bill Powers of Sagamore was the Upper Cape's most valuable pitcher, and teammate Bill Cleary received the MVP award. Presenting the awards were New York Yankees Phil Rizzuto (far left), Gil McDougal (fourth from left), and the voice of the Yankees, Mel Allen (sixth from left). (Courtesy Dudley Jensen.)

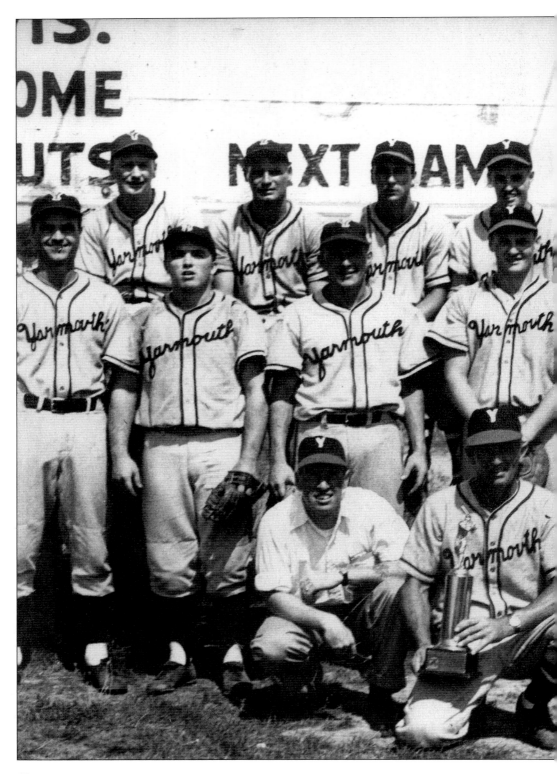

By 1958, many of the teams had a mix of local and outside players. The Yarmouth Indians that year had a roster that included college players, but also had a strong contingent of locals. Merrill "Red" Wilson, Jim Hubbard, and Bob Sherman led the team to the all-Cape championship that year, defeating Sagamore. Sherman was the winning pitcher when Yarmouth clinched it all on September 2, by a score of 4-3, which is reflected on the scoreboard behind the team. (Courtesy Jim Hubbard.)

Tony Cunha was a player for Falmouth in the 1950s before taking over as coach, then manager. The Falmouth All-Stars won the Upper Cape division in 1960 under Cunha's leadership with a record of 22-6, edging Cotuit by one game. Cunha went on to umpire in the league until 1970. (Courtesy Al Irish.)

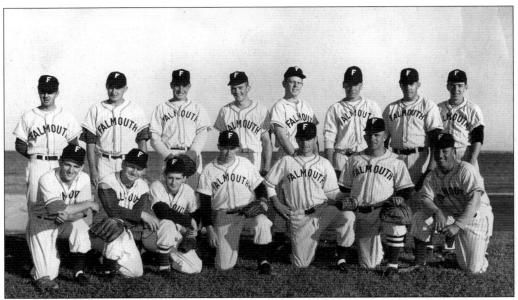

The Upper Cape champion 1960 Falmouth All-Stars lost to Sagamore in the Upper Cape playoffs. The Clouters faced Yarmouth in the all-Cape championship and lost. Falmouth last won the all-Cape championship in 1946. Six years later, in 1966, they would win it again. (Courtesy Al Irish.)

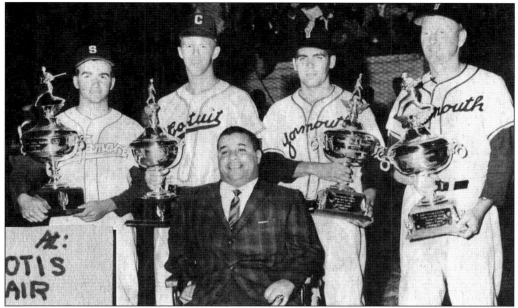

In 1961, the Upper and Lower Cape Leagues played their fifth-annual All-Star Game at Otis Air Force Base. The Upper Cape won 5-4. Here, with their trophies and former Brooklyn Dodger catcher Roy Campanella, are (from left to right) Jack McDonough, the Sagamore Upper Cape most valuable player; Dick Mayo, the Cotuit Upper Cape top pitcher; Dick Cassani, the Yarmouth Lower Cape top pitcher; and Merrill "Red" Wilson, the Yarmouth Lower Cape most valuable player. (Courtesy Dan Dunn Collectables.)

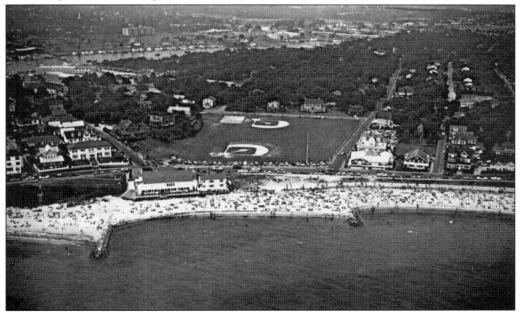

This aerial photograph of the fields at Falmouth Heights was taken just prior to the team's move to Guv Fuller Field in 1964. For almost 100 years, crowds gathered at this seaside spot to enjoy the sea, the sand, and baseball. (Courtesy Dan Dunn Collectables.)

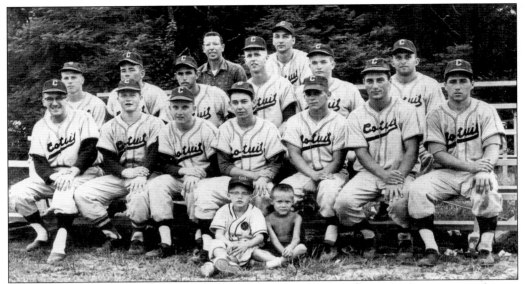

In the late 1950s and early 1960s, Cotuit had been gaining strength under the guidance of general manager Arnold Mycock, disputing the lock Sagamore seemed to have on the Upper Cape. In 1961, Mycock and field manager Jim Hubbard teamed up to dominate the league with four successive championships. The 1962 team pictured above recorded a record of 32-5 in their championship season. Mycock and Hubbard are together in the back row. (Courtesy Jim Hubbard.)

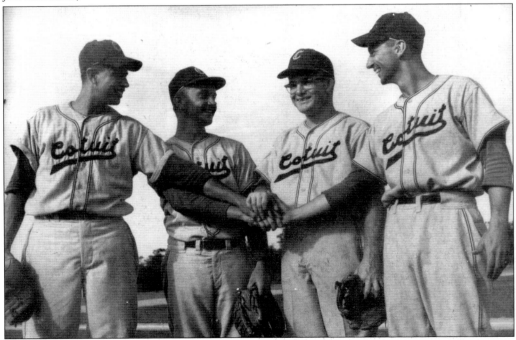

Cotuit Kettleer players Jeff Helzel and Bobby Butkus, Cape Cod Baseball League Hall of Famer Bernie Kilroy, and manager Jim Hubbard are together in this 1961 photograph. (Courtesy Jim Hubbard.)

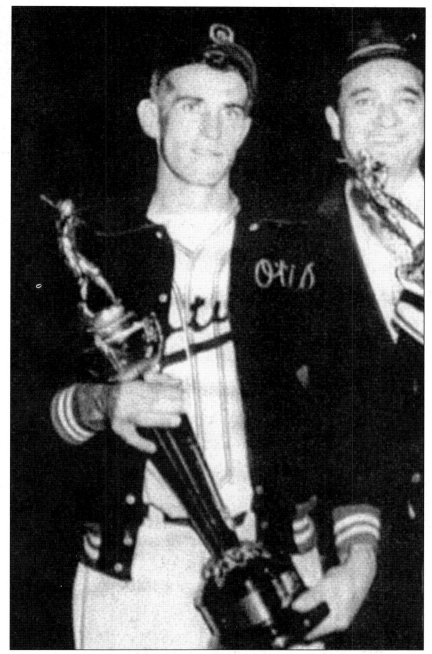

A native of Cotuit and graduate of Barnstable High School, Cal Burlingame played in the Cape League for the Cotuit Kettleers, the old Barnstable town team, and Yarmouth. He was named a Cape League all-star five times and was considered to be the best player of his time. A pitcher and outfielder, he played for Orleans in 1954, when they went to the National Baseball Congress Tournament in Wichita, Kansas. After a minor-league appearance with the Boston Red Sox, he returned to the Cape as an umpire. He was inducted into the Cape Cod Baseball League Hall of Fame in 2002. (Courtesy Heritage Museums and Gardens, Sandwich.)

Change was in the wind in 1963. It was felt that it would be better if the Upper and Lower Cape Leagues combined as the Cape Cod Baseball League. Former umpire-in-chief Danny Silva was given the task that year as the first commissioner to bring the leagues together as one. (Courtesy Heritage Museums and Gardens, Sandwich.)

Four
THE MODERN ERA BEGINS
1963–1987

The modern era of Cape League baseball began in 1963, when the Upper and Lower Cape Leagues merged. That same season, Ken Voges (who had played for Texas Lutheran) of the Chatham Red Sox hit for an all-time high average of .505. He won the batting title that year. Above, he is being presented with the trophy by new commissioner Danny Silva. (Courtesy Bruce Hack.)

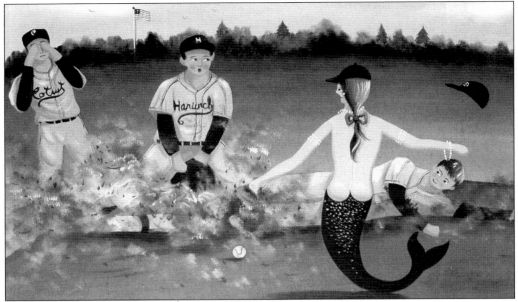

The championship run by Cotuit continued until 1964 under Arnold Mycock and Jim Hubbard. Baseball fan and local artist Ralph Cahoon enjoyed watching the Kettleers play and expressed his appreciation through his art in this painting done specifically for Hubbard and presented to him upon his retirement from the Cotuit dugout in 1969. (Courtesy Jim Hubbard.)

This work by Ralph Cahoon was a gift to Cotuit general manager Arnold Mycock. Again, Cahoon drew from his love of watching the Kettleers and Cape League baseball. (Courtesy Heritage Museums and Gardens, Sandwich.)

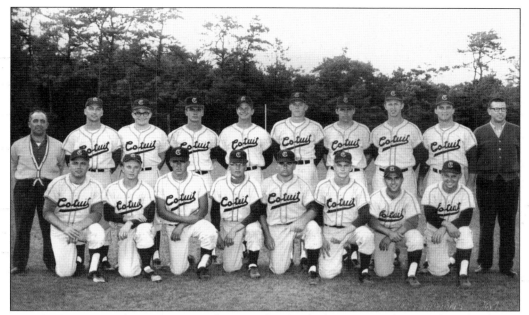

In 1964, Cotuit won the Cape League championship for the last time until 1972, when they began another four-year run. The Kettleers compiled a record of 46-5 that year because they played teams outside the league as well. The league was becoming more of a summer collegiate circuit. Four players from the 1964 Kettleers moved on to major-league careers. (Courtesy Jim Hubbard.)

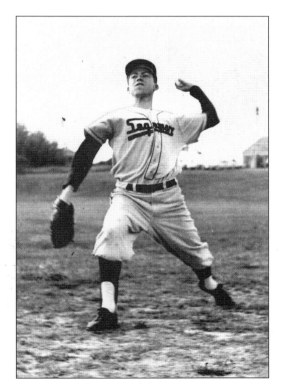

Noel Kinski was one of the top pitchers in the Cape League during the mid-1960s. He pitched for Bourne in 1964, then Sagamore in 1965, and Falmouth in 1966. A three-time all-star, the southpaw baffled hitters as he compiled a record of 10-1 in 1965 for the Clouters and had an ERA of 1.91. He pitched 11 complete games that year, struck out 85 batters, and allowed just 31 walks. He was inducted into the Cape Cod Baseball League Hall of Fame in 2003. (Courtesy Noel Kinski.)

Merrill "Red" Wilson has coached in the Cape League longer than any other manager, compiling 16 seasons (1966, 1968–1974, and 1979–1986) with the Yarmouth-Dennis Red Sox. He ranks third on the win list for managers, with a record of 257-373-33. He was inducted into the Cape Cod Baseball League Hall of Fame in 2000. The Yarmouth-Dennis field, home to the Red Sox, is named for Wilson. (Courtesy Cape Cod Times.)

Fred Ebbett managed the Harwich Mariners for five years during the 1970s, and later, he served as commissioner of the Cape Cod Baseball League (1984–1996). He was instrumental in returning the league to wooden bats in 1985 after 10 years of using aluminum. Ebbett was inducted into the Cape Cod Baseball League Hall of Fame in 2001 and is also enshrined in the Massachusetts Baseball Coaches Hall of Fame. (Courtesy Mary Henderson.)

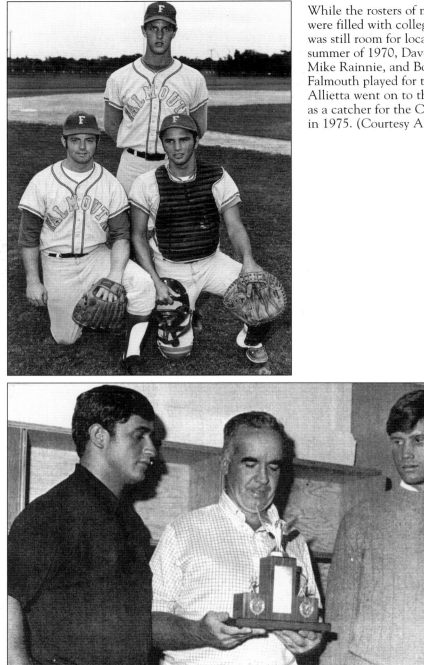

While the rosters of many Cape teams were filled with college players, there was still room for local stars. In the summer of 1970, Dave Creighton, Mike Rainnie, and Bob Allietta of Falmouth played for the Commodores. Allietta went on to the major leagues as a catcher for the California Angels in 1975. (Courtesy Al Irish.)

Falmouth put together a string of four Cape League championships, from 1968 to 1971. In this view, Falmouth baseball club president George Creighton holds the 1969 championship trophy. To the left is pitcher Paul Turco (Quinsigamond), and to the right is Paul Mitchell (Old Dominion), the league's outstanding pitcher that year. Mitchell led the league with an 8-3 record and ERA of 1.20. (Courtesy Al Irish.)

Cape Cod Baseball League Hall of Fame manager Jack McCarthy was in the second year of his nine seasons with the Kettleers in 1971. The 1971 team, pictured here, finished fourth that year with a record of 20-18-4. The next year, the team began a four-year championship run. McCarthy, who played for the Kettleers from 1962 to 1965, compiled a record of 208-153-15 with Cotuit, winning five titles. In 1975, he introduced the idea of youth clinics at Cotuit. (Courtesy Barnstable Patriot.)

The 1974 Orleans Cardinals finished the season with a record of 20-15-7, in second place in the east. They defeated Harwich in the playoffs but lost to Cotuit in the finals. Mike Kiner, the son of major-league Hall of Fame player Ralph Kiner, is No. 12 in the back row. Tom Yankus (No. 18) was the manager that year, his first of seven seasons with Orleans. (Courtesy Barry Kavanaugh.)

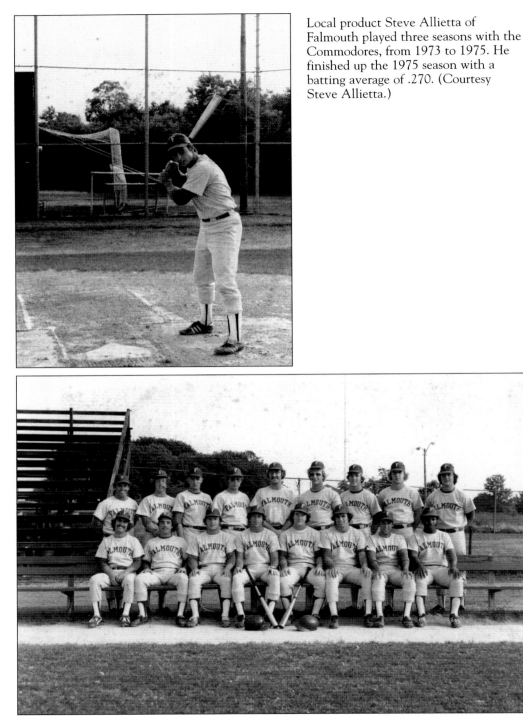

Local product Steve Allietta of Falmouth played three seasons with the Commodores, from 1973 to 1975. He finished up the 1975 season with a batting average of .270. (Courtesy Steve Allietta.)

The Falmouth Commodores finished the 1975 season in first place, with a record of 26-16. They eliminated Yarmouth-Dennis in the first round of the playoffs but lost to Cotuit in the finals. (Courtesy Steve Allietta.)

The new Hyannis Mets manager Ben Hays and Jack McCarthy, the skipper of the defending champion Cotuit Kettleers, meet prior to the first game of the 1976 season. When Bourne left the league after the 1975 campaign, Hyannis took its place. Hyannis had been without a team since 1958, when the Barnstable Red Sox left the league. The name Mets was chosen with the hope that the New York Mets might support the team. (Courtesy Barnstable Patriot.)

Cape Cod Baseball League Hall of Fame manager Ed Lyons managed for 15 years and brought Chatham a playoff title in 1982. He managed Wareham from 1970 to 1975 and twice took his team to the playoffs. From 1976 to 1982, he managed Chatham, finishing in first place twice but was eliminated in the playoffs. He finished his Cape League managerial career in 1989 with Hyannis. (Photograph by Stu Eastman, courtesy Cape Cod Times.)

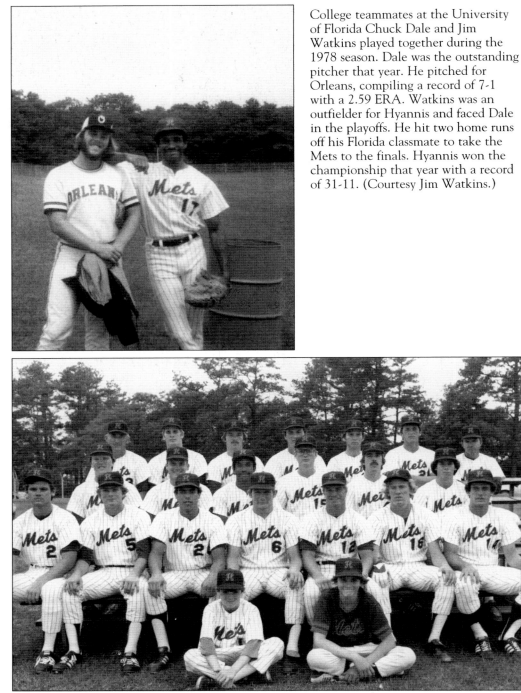

College teammates at the University of Florida Chuck Dale and Jim Watkins played together during the 1978 season. Dale was the outstanding pitcher that year. He pitched for Orleans, compiling a record of 7-1 with a 2.59 ERA. Watkins was an outfielder for Hyannis and faced Dale in the playoffs. He hit two home runs off his Florida classmate to take the Mets to the finals. Hyannis won the championship that year with a record of 31-11. (Courtesy Jim Watkins.)

The 1978 Hyannis Mets set the team batting average record with a mark of .313. The next year, the 1979 Mets broke the record with a .314 average. The 1978 squad still holds the slugging percentage record with a mark of .498. They set the home run record that year with 53—a mark that was later broken by Orleans in 1981 with 59. (Courtesy Jim Watkins.)

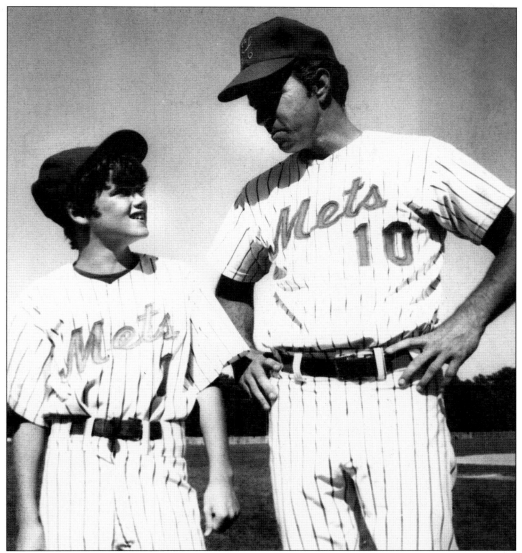

Hyannis Mets bat boy Patrick Aylmer was 11 years old when this 1978 photograph was taken. The team had been in the league just three seasons and that year won the Cape League championship. Aylmer is pictured with coach Bob Schaefer in this end-of-the-season picture as they agree that winning has a nice feeling to it. (Courtesy Barnstable Patriot.)

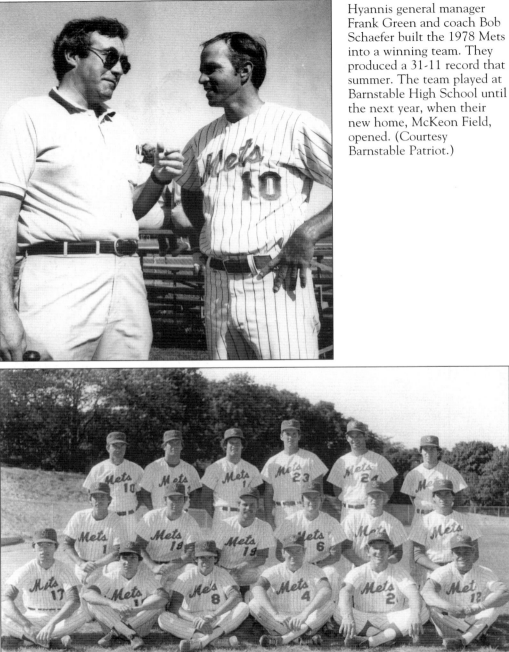

Hyannis general manager Frank Green and coach Bob Schaefer built the 1978 Mets into a winning team. They produced a 31-11 record that summer. The team played at Barnstable High School until the next year, when their new home, McKeon Field, opened. (Courtesy Barnstable Patriot.)

Hyannis added a second consecutive championship under coach Bob Schaefer in 1979. The team finished the season with a record of 33-7-1. The batting champion that year was Ross Jones (Miami), on the far left in the second row, who hit .407. He also received the Outstanding Pro Prospect Award that year. Ron Perry (Holy Cross), third from the left in the back row, was the league MVP in 1979 and was inducted into the Cape Cod Baseball Hall of Fame in 2003. (Courtesy Barnstable Patriot.)

Local kids on the Cape grow up aspiring to play in the Cape League. They collect autographs and follow their favorite players over the course of the summer. Some are lucky enough to become bat boys for their favorite teams. In 1976, Willie Rapp (left) and Al Murphy, shown here during the singing of the national anthem, got the Cotuit dugout job. (Courtesy Barnstable Patriot.)

Fresh off the Little League fields of the Cape, kids relish the excitement of a late-day or evening Cape League game. To have the opportunity to mingle with their heroes and watch the game from the dugout is a special experience. Taking a break before a Harwich Mariners game, 12-year-old Chris Henderson appears to eye a ball heading for the fence. (Courtesy Mary Henderson.)

In 1978, Bill Schroeder (Clemson) of the Hyannis Mets was the league's most valuable player and won the Outstanding Pro Prospect Award. He holds the mark as having the most home runs hit by a catcher, with 15 that year. He is currently the television broadcaster for the Milwaukee Brewers. (Photograph by Gordon E. Caldwell, courtesy Cape Cod Times.)

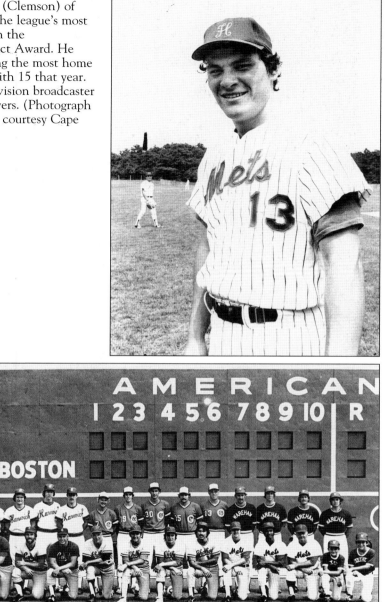

The 1977 all-star team pictured here defeated the Atlantic Collegiate League 8-3. No. 25 for the Yarmouth-Dennis Red Sox, sixth from the right in the back row, is the game MVP Steve Balboni (Eckerd). He hit two huge three-run home runs that day. He was also the league MVP that year and shared the Outstanding Pro Prospect Award with Brian Denman (Minnesota) of Cotuit. Balboni had an 11-year major-league career. (Courtesy Jim Watkins.)

John Castleberry managed the Orleans Cardinals from 1984 to 1991, going 170-164-10 and winning the league title in 1986. Castleberry is 10th on the all-time win list for Cape Cod Baseball League managers but first in wins for the Cardinals. (Photograph by Sherwood Landers, courtesy Cape Cod Times.)

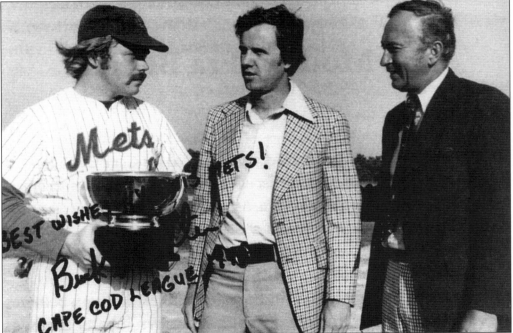

Nat "Buck" Showalter played for the Hyannis Mets in 1976. He won the batting title hitting .434 that year. He hit the first home run for the new franchise in 1976 and is shown here receiving the league's MVP award. He went on to manage the New York Yankees, Arizona Diamondbacks, and Texas Rangers. In 2002, he was inducted into the Cape Cod Baseball League Hall of Fame. (Courtesy Jack Aylmer.)

Mike Yastrzemski (Florida State) played three seasons for the Harwich Mariners, from 1980 to 1982. Like his famous father, he had a good eye at the plate, hitting .299 in 1982. During Yastrzemski's time in the Cape League, aluminum bats were used. Here, he is warming up with wood because it was the way his father preferred. (Courtesy Mary Henderson.)

In 1980, the Falmouth Commodores won the Cape League championship with a record of 26-15-1. They finished second in the standings, defeated Cotuit in the first round of the playoffs, and knocked off Chatham in the finals. In this photograph, Sid Bream (Liberty), seen facing the camera in the center, is being congratulated after a hitting a home run. He went on to a 12-year major-league career. (Photograph by Rob Schloerb, courtesy Cape Cod Times.)

Wade Rowdon (Stetson) of the Orleans Cardinals is congratulated after hitting a home run in 1981 at Fenway Park in Boston at the All-Star Game against the Atlantic Collegiate League. The game ended in a 4-4 tie. Rowdon is getting a high-five from John Morris of the Wareham Gatemen as he crosses the plate. (Photograph by Stu Eastman, courtesy Cape Cod Times.)

Terry Steinbach (Minnesota) won the batting title with a .431 average in 1982 and was named the most valuable player. He compiled a league-best 75 hits, 129 total bases, and 54 runs batted in that year. Steinbach was named to the all-league team and was a starter in the All-Star Game. He went on to have a 14-year major-league career. In 2001, he was inducted into the Cape Cod Baseball League Hall of Fame. (Photograph by Ron Schloerb, courtesy Cape Cod Times.)

The 1982 Falmouth Commodores pose on the old wooden bleachers at Guv Fuller Field. (Courtesy Al Irish.)

In 1984, the Orleans Cardinals finished third at 23-18-1. They were eliminated in the playoffs by eventual league champion, Cotuit. Second from the left in the back row is assistant coach Dave Littlefield, who is now the general manager of the Pittsburgh Pirates. Third from the right in the same row is pitcher Erik Hanson (Wake Forest), who later pitched 11 years in the major leagues. (Courtesy Sue Horton.)

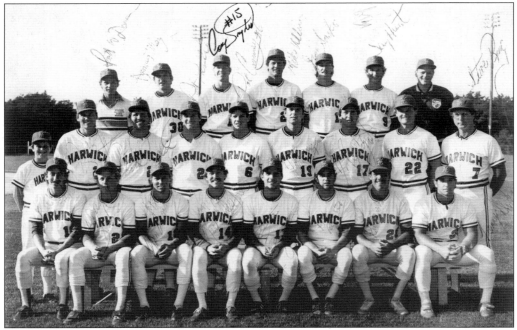

The 1983 Harwich Mariners won the Cape League championship with a record of 24-17-1. Cory Snyder (Brigham Young University), third from the left in the back row, hit 22 home runs that year, still a Cape League record. Snyder later played in the major leagues for nine years. (Courtesy Julie Santoni.)

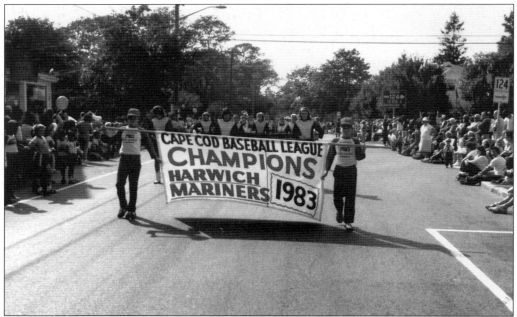

Cape League teams have traditionally taken part in local Fourth of July parades. In 1984, the Harwich Mariners had plenty to celebrate as the defending league champions. (Courtesy Mary Henderson.)

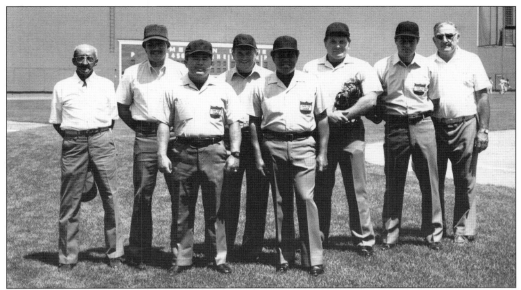

Seen in this 1983 All-Star Game photograph at Fenway Park are, from left to right, Cape League umpires Manny Pina, Ed Gendron, Jim McCullough, George Pribish, Clarence Merritt, Jim Rondo, Ed Martin, and Archie Allen. The Cape League defeated the Atlantic Collegiate League 6-2. Two members of the team were Will Clark (Mississippi State) and Cory Snyder. (Courtesy Ed Gendron.)

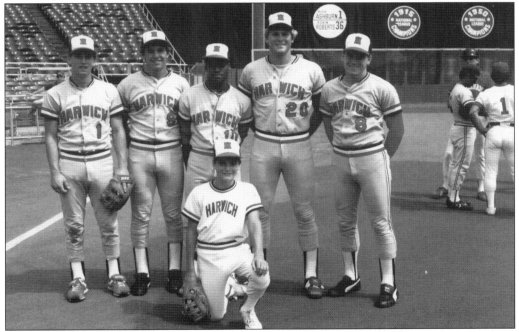

In 1984, the All-Star Game with the Atlantic Collegiate League was held at Veterans Stadium in Philadelphia. In the middle in this photograph is Mike Loggins (Arkansas), who was the game MVP. To his left is Joe Magrane (Arizona), who was the winning pitcher. The Cape League won 7-3. (Courtesy Mary Henderson.)

Yarmouth-Dennis shortstop Mickey Morandini (Indiana) won the batting title in 1987 and was named league MVP. He led the league in runs (46), hits (62), doubles (15), total bases (91), and stolen bases (43). In 1987, he was the starting shortstop in the All-Star Game played against the Atlantic Collegiate Baseball League at Fenway Park in Boston. He was also selected to the Cape League all-league team that year. Morandini went on to have a successful major-league career. (Courtesy Cape Cod Times.)

Robin Ventura (Oklahoma State) came to the Cape League in 1987 after a National Collegiate Athletic Association Division I–record 58-game hitting streak. He was named the Outstanding Pro Prospect and was selected to the all-league team that summer. Hyannis lost to Yarmouth-Dennis in the playoffs that year. Ventura is the winner of six Gold Gloves at third base in the major leagues and is the active leader in career grand slams with 16. (Courtesy Cape Cod Times.)

The Cape Cod Baseball League is run by volunteers who have their hearts in baseball. There is no charge for admission to a Cape League game. The franchises raise money through passing the hat, fifty-fifty drawings, and raffles. A scene like this is common at Cape League fields. As the fans enjoy the game, volunteers work behind the scenes to make it all run. (Courtesy Barnstable Patriot.)

Laurie Marcoux is helping to pass the hat at a Hyannis Mets game in 1980. The defending champion Mets finished the season that summer with a record of 18-23-1 but led the league in hitting with a .299 average. (Courtesy Tim Ellstrom.)

In 1987, Judy Walden Scarafile was the league vice president. Fours years later, in 1991, she took over the presidency and has guided the Cape Cod Baseball League into the 21st century, making it the top summer collegiate league in the country. (Photograph by Frank Finn, courtesy Cape Cod Sports Report.)

Five

EXPANSION AND THE 1990S
1988–1999

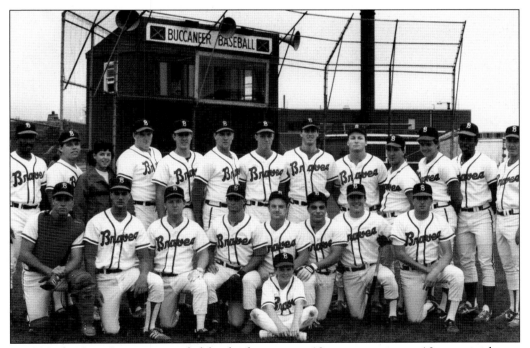

In 1988, the Cape League expanded for the first time in 12 years, growing to 10 teams with east and west divisions. Bourne played in the west division, while the new Brewster Whitecaps joined the east. The Bourne Braves finished their inaugural season with a record of 12-29-3, and Brewster posted a record of 17-25-2. Bourne played at Massachusetts Maritime Academy and Brewster played at Cape Cod Regional Technical High School. (Courtesy Bob Corradi.)

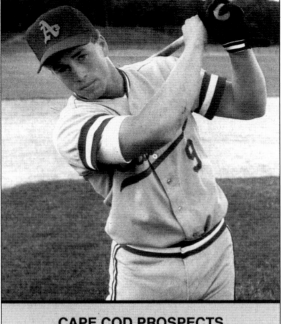

The only year the Cape League produced baseball cards was 1988. Jeff Bagwell (Hartford) was an all-star with the Chatham A's. He hit .315 with 6 home runs and 22 runs batted in. Bagwell was the fourth-round draft pick of the Boston Red Sox in 1989. He was the first Cape Leaguer to hit 400 home runs in the major leagues. His entire major-league career has been spent with the Houston Astros. (Courtesy Bruce Hack.)

CAPE COD PROSPECTS
JEFF BAGWELL – 3B
CHATHAM A's

Chuck Knoblauch (Texas A&M) played for the Wareham Gatemen in 1988. That year, he won the batting title with an average of .361. He also won the league's Outstanding Pro Prospect Award. He went on to a major-league career, where he won the 1991 Rookie of the Year and World Series titles with Minnesota and the New York Yankees. (Courtesy Bruce Hack.)

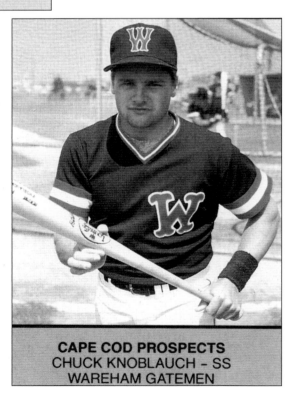

CAPE COD PROSPECTS
CHUCK KNOBLAUCH – SS
WAREHAM GATEMEN

In addition to their prospect card set, the league produced team sets in 1988. J. T. Snow (Arizona) played first base that season for Orleans and still holds the record for putouts by a first baseman with 21 in a single game. Drafted in the fifth round in 1989 by the New York Yankees, he has won six Gold Gloves at first base in his major-league career. (Courtesy David Mitchell.)

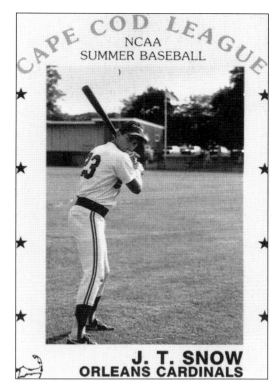

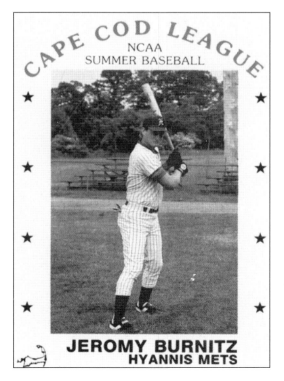

Jeromy Burnitz (Oklahoma State) was an outfielder for the Hyannis Mets in 1988. He hit .234 and helped the Mets to a 26-17-1 record and a second-place finish. He was a first-round pick of the New York Mets in 1990 and is still active in the major leagues. (Courtesy Tim Ellstrom.)

91

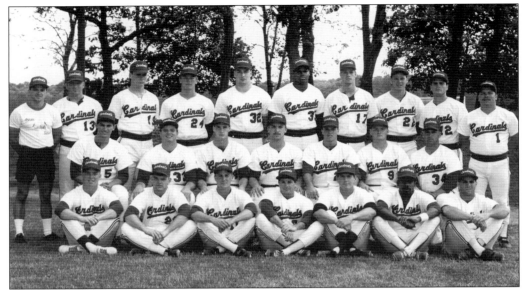

In 1988, the Orleans Cardinals posted a record of 22-20-2 and lost to Wareham in the playoffs. Future major-leaguers Frank Thomas (Auburn), J. T. Snow, Jesse Levis (North Carolina), Brian Barnes (Clemson), and Brian Bark (North Carolina State) were all members of the team. (Courtesy Sue Horton.)

After the 1988 season, the Cape League joined three other summer leagues in Davenport, Florida, at the new Kansas City Royals spring-training facility for the Boardwalk and Baseball Tournament. The Cape League squad assembled just for this tournament dropped the opening-round game but came back to win the tournament. The other three teams used aluminum bats, while the players from the Cape hit with wood. Chuck Knoblauch, Mo Vaughn, Jeff Bagwell, Tim Salmon (Grand Canyon), and Eric Wedge (Wichita State) played for the Cape. (Courtesy David Mitchell.)

In the early 1990s, the Bourne Braves played at Massachusetts Maritime Academy in Buzzards Bay. The Cape Cod Canal Railroad bridge is in the background. (Courtesy Falmouth Enterprise.)

In just their second season in the league, the Bourne Braves won the Cape Cod Baseball League western division championship, posting a record of 24-17-3. Yarmouth-Dennis under Don Reed won the title that year. Mark Johnson (Dartmouth), who later played for Pittsburgh, Anaheim, and the New York Mets, hit .280 that year for Bourne. (Courtesy Ed Gendron.)

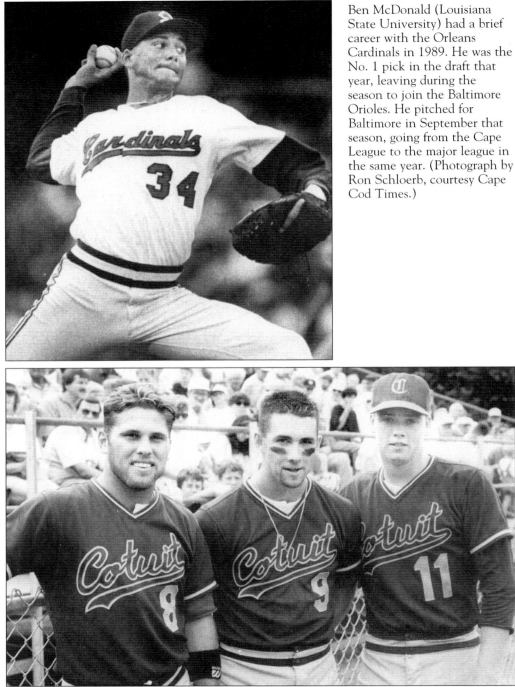

Ben McDonald (Louisiana State University) had a brief career with the Orleans Cardinals in 1989. He was the No. 1 pick in the draft that year, leaving during the season to join the Baltimore Orioles. He pitched for Baltimore in September that season, going from the Cape League to the major league in the same year. (Photograph by Ron Schloerb, courtesy Cape Cod Times.)

In 1992, three Cotuit players topped the charts in the Cape League. Rick Ellstom (Miami), left, was the league MVP; Lou Merloni (Providence), center, won the batting title hitting .321 and the Danile J. Silva Sportsmanship Award; John Kelly (Connecticut), right, was the outstanding pitcher, going 7-1 with a 1.20 ERA. (Photograph by Ron Schloerb, courtesy Cape Cod Times.)

Doug Glanville (Pennsylvania) played for Wareham in 1990. He hit .331 that summer to help the Gatemen to the western division championship with a record of 24-19-1. Wareham lost in the finals to Yarmouth-Dennis. Glanville was named the Cape League's Outstanding Pro Prospect and was selected to the all-league team. He was a 1991 first-round draft pick of the Chicago Cubs, taken immediately ahead of Manny Ramirez. He has played in the major leagues since 1996. (Courtesy Cape Cod Times.)

Mark Smith (University of Southern California) was with Wareham in 1990. He won the batting title that summer with an average of .408 and is the last Cape League player to hit over .400. He is also the only player to hit over .400 since the return of wooden bats in 1985. He was named league MVP and was selected to the all-league team that year. The Gatemen won the western league title that summer but lost in the finals to Yarmouth-Dennis. (Courtesy Cape Cod Times.)

Bourne right-handed pitcher Ron Villone (University of Massachusetts) pitched in just two Cape League games before rejoining Team USA for the 1992 Olympics. He set a team record with 18 strikeouts in his Cape debut, and the next time he took the mound, he struck out 14 batters in 6.1 innings of work. He holds the Cape League record for strikeouts in two consecutive games with 32. Villone pitched in the major leagues for Seattle and San Diego in 1995 and went on to play for Milwaukee, Cleveland, Cincinnati, Houston, and Pittsburgh. (Courtesy Cape Cod Times.)

One of the hardest-throwing pitchers in league history, Billy Wagner (Ferrum College) pitched for Brewster in 1992. He holds the league record for strikeouts per nine innings, with 79 in 44.1 innings for an average of 16. He also holds the NCAA Division III career record with 16 strikeouts per nine innings. Wagner was named the Outstanding Pro Prospect that summer and has become one of the top closers in the major leagues. (Photograph by Ron Schloerb, courtesy Cape Cod Times.)

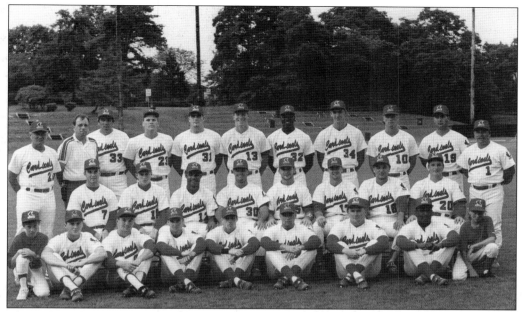

The 1990 Orleans Cardinals posted a record of 24-20, second in the east. They lost in the playoffs to Yarmouth-Dennis, the eventual winner. Mike Kelly (No. 32) was the second overall pick in the draft the next year by the Atlanta Braves. The bat boy was Paul Reuland (on the far left in the front row), and the bat girl was Holly Tyng (on the far right). (Courtesy Sue Horton.)

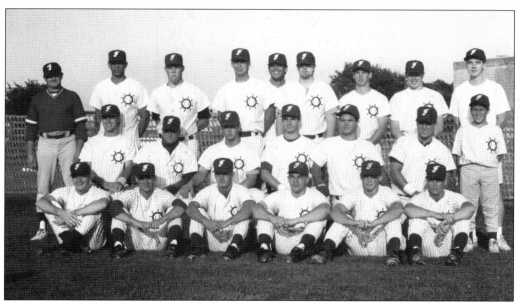

In 1991, Falmouth sported a new look with the baseball-within-a-ship's-wheel insignia. Commodore infielder Mark Loretta (Northwestern) was a seventh-round draft pick in 1993 by the Milwaukee Brewers. The Commodores were coached by Dan O'Brien, a former Chatham player. He still holds the Chatham strikeout record of 122 strikeouts in 110 innings. (Courtesy Dan Dunn Collectables.)

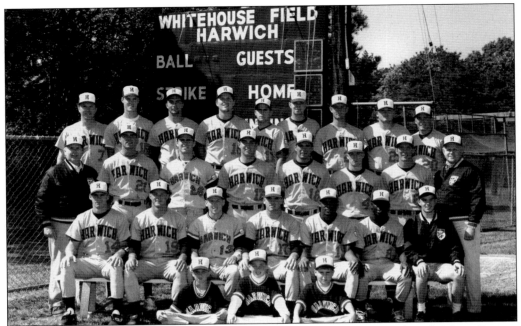

The 1992 Harwich Mariners are posed here in front of their old scoreboard. Major League Baseball commissioner Fay Vincent donated a new electronic scoreboard that dominates right-center field today. Steve Ring coached the Mariners in 1992. They finished with a record of 20-23-1 and were third in the east. (Courtesy Mary Henderson.)

The Wareham Gatemen finished the season with a 22-20-1 record in 1992. They finished second in the west and lost to Cotuit in the first round of the playoffs. (Courtesy Jim Hubbard.)

Todd Walker (Louisiana State University) hit .272 for the Brewster Whitecaps in 1992. Brewster finished second in the east that year but lost in the playoffs to Chatham. In 1992, Walker was the National Freshman of the Year when he hit .400 for Louisiana State University. The next year, he was the NCAA Division I leader in runs batted in with 102. He has played in the major leagues since 1996. In this picture, Walker just beats the tag of Falmouth's Mark Loretta. (Photograph by Karl Leitz, courtesy Cape Cod Times.)

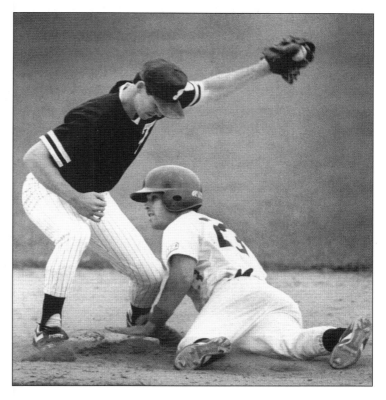

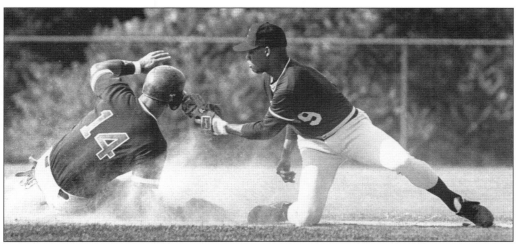

Damon Buford (University of Southern California), the son of former major-leaguer Don Buford, played for two years in the Cape League. In 1989, he was with Cotuit, where he hit .270 and stole 23 bases. That year, he was a teammate of Darren Bragg (Georgia Tech), Scott Erickson (Arizona), and David McCarty (Stanford). In 1990, he played for Brewster and hit .291. He was drafted by the Baltimore Orioles in the tenth round of the 1990 draft. (Photograph by Tory Reed, courtesy Cape Cod Times.)

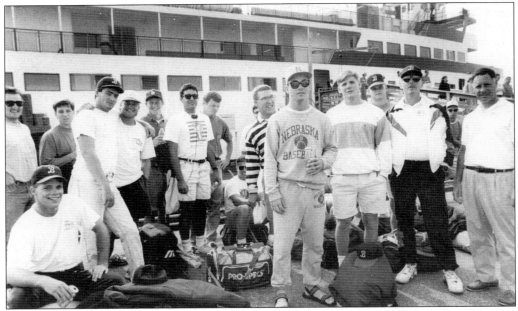

On July 1, 1992, the Brewster Whitecaps and the Bourne Braves made the trip from Hyannis to the island of Nantucket on board the ferry *Eagle*. It was the first time in the modern era that Cape Cod Baseball League teams played on Nantucket. Bourne won 7-4 on Australian Stuart Thompson's (Alabama Birmingham) pinch-hit three-run home run. Willard Brown (Stetson) was the winning pitcher. The game was called the Expansion Cup. (Photograph by Gordon E. Caldwell, courtesy Cape Cod Times.)

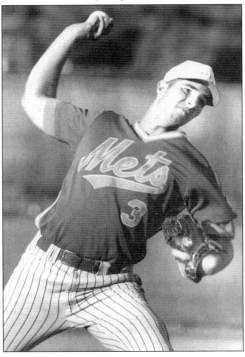

In 1993, Matt Morris (Seton Hall) pitched for Hyannis, finishing the season with a record of 7-2 and a 2.24 ERA. He was the winning pitcher for the west in that summer's All-Star Game and was named to the all-league squad. His battery mate that season was Cape Cod Baseball League Hall of Famer Jason Varitek (Georgia Tech). He was the only pitcher to toss a no-hitter that year and was a 1995 first-round pick of the St. Louis Cardinals. (Photograph by Kevin Wisniewski, courtesy Cape Cod Times.)

Aaron Boone (University of Southern California) hit .250 with two home runs and 25 runs batted in for the Orleans Cardinals in 1993. He was drafted in the third round in 1994 by the Cincinnati Reds. In 2003, he broke the hearts of Red Sox fans and his former Orleans teammate, Nomar Garciaparra, with an 11th-inning home run to send the New York Yankees to the World Series. (Photograph by Ron Schloerb, courtesy Cape Cod Times.)

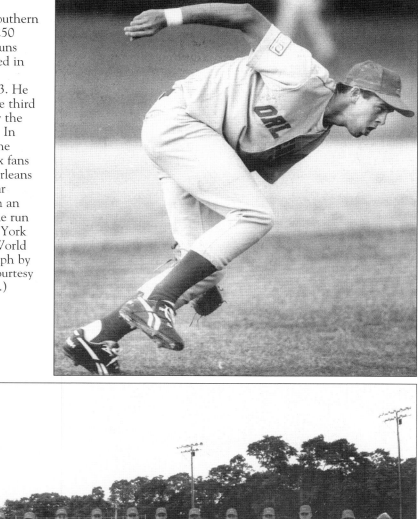

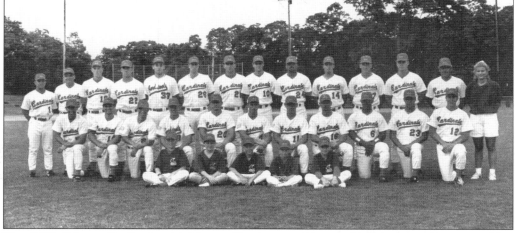

The 1993 Orleans Cardinals with Nomar Garciaparra (Georgia Tech), Aaron Boone, and Jay Payton (Georgia Tech) finished second in the east with a record of 23-20-1 but fought their way into the finals, where they defeated Wareham for the Cape League championship. (Courtesy Sue Horton.)

Ryan Kinski (Providence) is a second-generation Cape League player. Following in the footsteps of his father, Noel Kinski, he played for Chatham in 1995. The A's won the east that summer but lost in the finals to Cotuit. Kinski was an assistant coach for the Hyannis Mets in 2003. (Courtesy Noel Kinski.)

Falmouth's Mike Pasqualicchio (Lamar) watches on a sunny Cape Cod afternoon in 1994 as the Commodores drive to a record of 26-16-1 and the western division championship. Pasqualicchio was a second-round pick of the Milwaukee Brewers in 1995. (Courtesy Falmouth Enterprise.)

Kids are always anxious to help. Here, 12-year-old Elizabeth Kennedy and 9-year-old Naunie Pires get a lesson in baseball from the umpire. (Courtesy Falmouth Enterprise.)

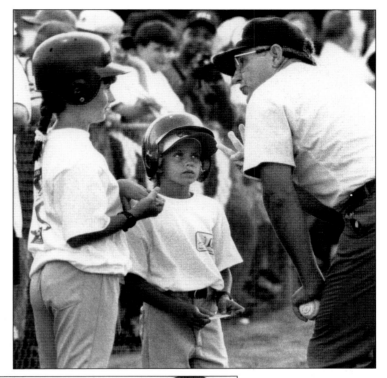

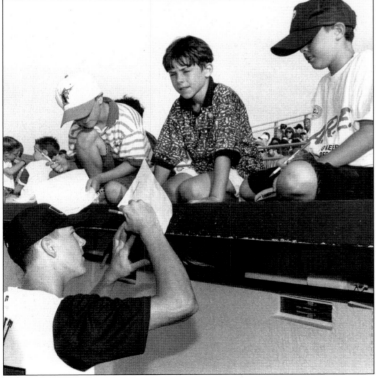

Teams and players from around the country and the world come to the Cape in the summer. Regardless of the team, there is always a group of young fans anxious for an autograph. (Courtesy Falmouth Enterprise.)

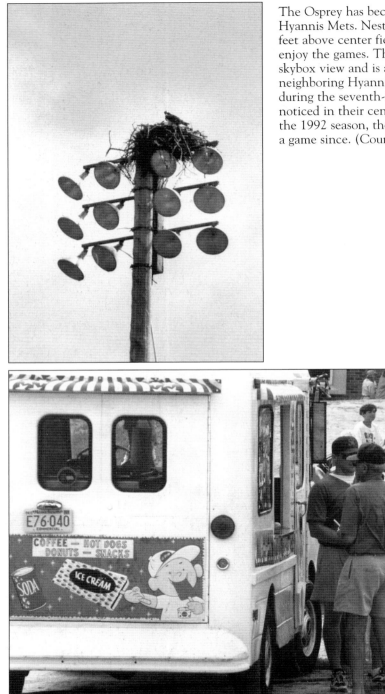

The Osprey has become a symbol of the Hyannis Mets. Nesting each summer 90 feet above center field, the birds seem to enjoy the games. The light pole offers a skybox view and is an easy glide to neighboring Hyannis harbor for a snack during the seventh-inning stretch. First noticed in their center-field perch before the 1992 season, the birds have not missed a game since. (Courtesy Tim Ellstrom.)

The local ice-cream man knows where to find the kids. But on this trip to the ball field, the kids turned out to be a group of hungry Cape Leaguers looking for a cold treat. (Courtesy Tim Ellstrom.)

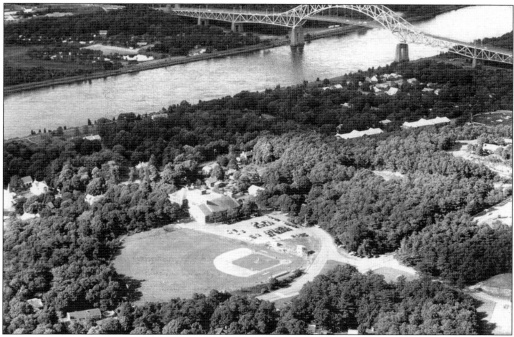

The Bourne Braves left the only home they had known at Massachusetts Maritime Academy since rejoining the league in 1988 and moved to Coady Field, on the Cape side of the bridge, for the 1996 season. The Cape Cod Canal and the Bourne Bridge are both nearby. (Photograph by Aerial Photography of Cape Cod, courtesy Paul Andrews.)

In 1996, the Braves went 18-25-1 and finished fifth in the west. Jerry Hairston Jr. (Southern Illinois) was the team's leading hitter with a .281 average. Hairston went on to play for the Baltimore Orioles. Dan Reichert (Pacific) pitched for Bourne that summer and later played for the Toronto Blue Jays. (Courtesy Lynn Ladetto.)

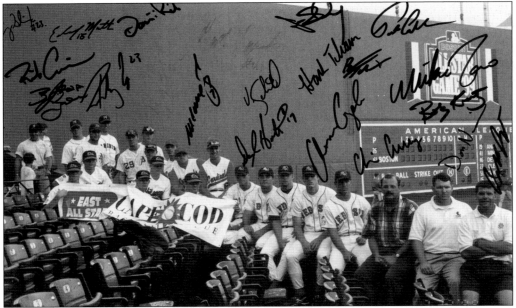

The eastern division Cape League all-stars enjoy a day at Fenway Park in Boston in 1998. The All-Star Game, played at Chatham's Veterans Field, was won by Jeremy Ward (Long Beach State) of the A's in a close 3-2 battle. Bobby Kielty of Brewster (Mississippi) was the league MVP and batting champion that summer with an average of .384. (Courtesy Sue Horton.)

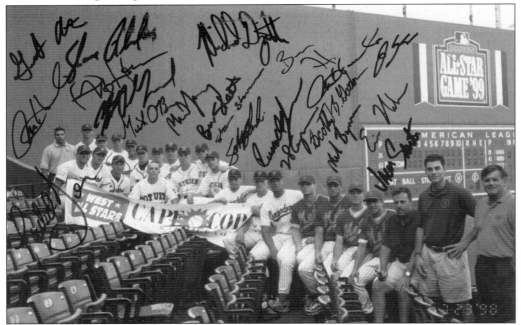

Also at Fenway that year were the western division Cape League all-stars. Ben Sheets (Northeastern Louisiana) played for Wareham that year. Sheets would later pitch a 4-0 shutout over Cuba in the gold-medal game of the 2000 Olympics in Sydney and go on to a major-league career. (Courtesy Lynn Ladetto.)

One of the legends of the Cape League, Ivan Partridge, is known best for coining the phrase "Have a hit." Whenever a Cotuit player steps to the plate, no matter whether on the Cape or in the major leagues, the call of "Have a hit" will draw their attention. Pressed close to the fence and surrounded by his granddaughter Rebecca, daughter Joan, and granddaughter Jessica Zanotti, he rarely misses a game at Lowell Park. (Courtesy Ivan Partridge.)

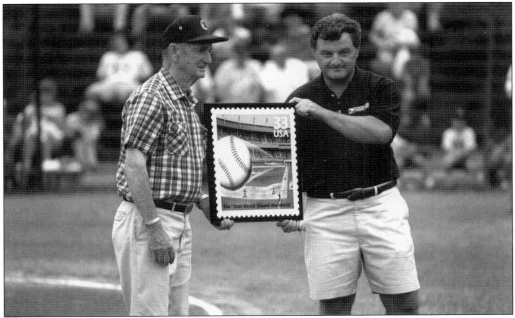

As part of their Century Collection, the U.S. Postal Service unveiled the "Shot Heard Round the World" stamp at Cotuit Kettleers game in 1999. Kettleer representative Mo Sherman and Cotuit postmaster Jim Sheehan display the new 33¢ stamp. (Photograph by Frank Finn, courtesy Cape Cod Sports Report.)

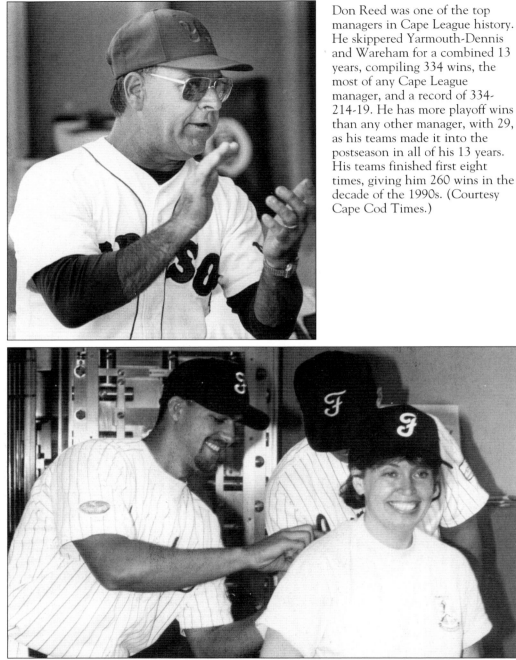

Don Reed was one of the top managers in Cape League history. He skippered Yarmouth-Dennis and Wareham for a combined 13 years, compiling 334 wins, the most of any Cape League manager, and a record of 334-214-19. He has more playoff wins than any other manager, with 29, as his teams made it into the postseason in all of his 13 years. His teams finished first eight times, giving him 260 wins in the decade of the 1990s. (Courtesy Cape Cod Times.)

In 1996, Falmouth Commodore players Eric Milton (Maryland), left, and Kris Wilson (Georgia Tech) sign the tee shirt of Plymouth Savings Bank representative Barbara Stackhouse. Milton holds the league record with a 0.21 ERA. He is also the only pitcher to toss a no-hitter in the Cape League as well as in the majors. His catcher when he pitched his no-hitter for the Minnesota Twins was Cape Cod Baseball League Hall of Famer Terry Steinbach. (Courtesy Cape Cod Times.)

Six

THE NEW CENTURY
2000–2003

The Wareham Gatemen, the most successful team of the 1990s, carried their winning tradition forward into the new century with championships in 2001 and 2002. (Courtesy Sean Walsh.)

General manager of the Wareham Gatemen since 1997, John Wylde doubles as official statistician for the league. Since Wylde became general manager, the Gatemen have won the league championship in 1997, 2001, and 2002. (Courtesy Sean Walsh.)

Longtime Cotuit general manager, Cape League official, and member of the Cape Cod Baseball League Hall of Fame Arnold Mycock helped lead the Kettleers to a dozen Cape League championships since joining the franchise in the early 1960s. Today, Mycock acts as the Cotuit general manager emeritus. (Courtesy Rick Heath.)

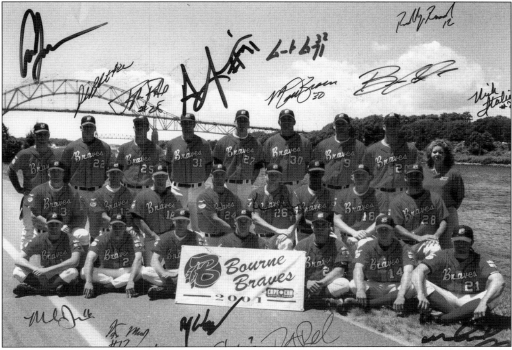

The 2001 Bourne Braves posed for this picture next to the Cape Cod Canal with the Bourne Bridge and railroad bridge in the background. (Courtesy Lynn Ladetto.)

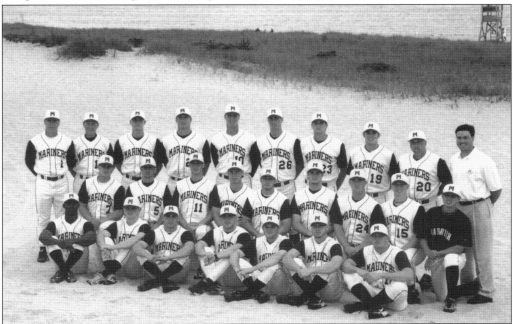

In 2000, the Harwich Mariners took a short trip to the beach for their team photograph. Sand dunes, salt water, and baseball typify what it is like to play on the Cape in the summer. That year, the Mariners finished the season with a record of 21-21. (Courtesy Mary Henderson.)

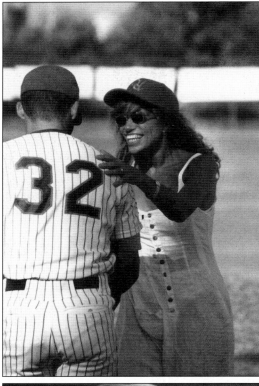

Martha's Vineyard resident Carly Simon, a Hyannis Mets fan, is seen at McKeon Field on July 11, 2000, before a game. The popular recording artist from the neighboring island thrilled a crowd of about 1,000 fans and received a commemorative bat marking her visit. (Courtesy Sean Walsh.)

Hyannis Mets assistant coach Nick Siemasz has worked with several Cape League teams, including Falmouth and Wareham. He has been involved in Cape League baseball for more than 20 years. (Courtesy Sean Walsh.)

After a day at the beach, kids flock to the fields to watch their favorite players and get autographs from those they hope will be future major-leaguers. Here, Hyannis Mets Slugger Brian Stavisky (Notre Dame) signs an autograph for Conor Walsh. (Courtesy Sean Walsh.)

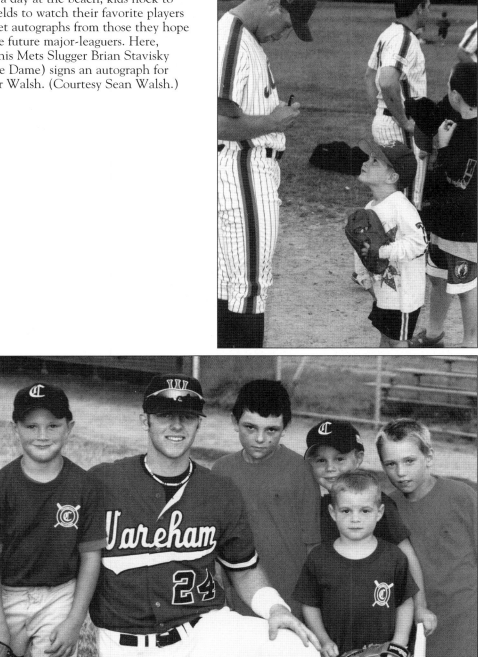

Matt Murton (Georgia Tech), an outfielder for the Wareham Gatemen, was the 2001 Cape League MVP. He is shown here with young fans, including Everett Walsh (far left). Also seen are George Bent, Mark Brodd, Donnie Brodd, and Jon Hegarty. Murton was the 2003 first-round supplemental draft pick of the Boston Red Sox. (Courtesy Sean Walsh.)

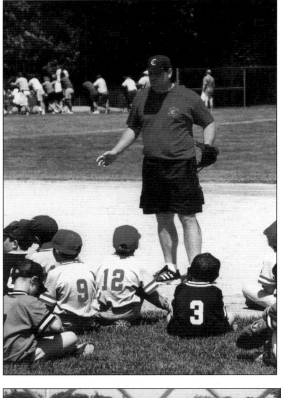

Cotuit Kettleer coach Mike Coutts talks with a group of Little Leaguers before a game. Kid-friendly, the Cape League draws plenty of young fans, and the family atmosphere offers them the chance to have some fun. (Courtesy Sean Walsh.)

Over the course of the summer, Cape League teams conduct clinics for local kids where the players from around the country teach the fundamentals of the game to future Cape Leaguers. (Courtesy Jean Flynn.)

In the Cape League, players enjoy meeting their fans after a game. This young fan at Red Wilson field in Yarmouth is not only enjoying the ride on the shoulders of Chuck Bechtel (Marist College) but is about to get a souvenir baseball from John Baker (now with the Oakland A's) to take home. (Courtesy Sean Walsh.)

This lucky fan managed to grab the ball Falmouth first baseman Joey Metropoulos (University of Southern California) launched out of Guv Fuller Field for a grand-slam home run on July 7, 2003. Metropoulos led the league that year with 11 home runs. Falmouth beat Cotuit 12-2, and after the game, Metropoulos was nice enough to sign the ball. (Photograph by Dan Webb, courtesy Falmouth Enterprise.)

At this 1999 Orleans youth clinic, players Shawn Weaver (Old Dominion), Tim Hummel (Old Dominion), Keith Stamler (St. Johns), Peter Bauer (South Carolina), and Dave Pember (Western Carolina) of the Cardinals are surrounded by kids. Hoisted above the rest are Danny and Mickey DeFilippo. The boys are Connecticut residents but would not miss a summer of Cardinals baseball. (Courtesy Sue Horton.)

After a game, fans mingle on the field with the players. While some collect autographs, others are lucky enough to get the chance to sit and talk with their heroes. Here, Bourne's Mike Malott (San Jose State) chats with an admiring fan. (Courtesy Lynn Ladetto.)

Local radio personality and Bourne announcer Kevin McGonagle not only keeps the fans informed but entertains the crowds between innings with cuts from his wide selection of music. The scoreboard operator, official scorer Will Bussiere, and internet broadcasters also occupy the press box. (Photograph by Dan Webb, courtesy Falmouth Enterprise.)

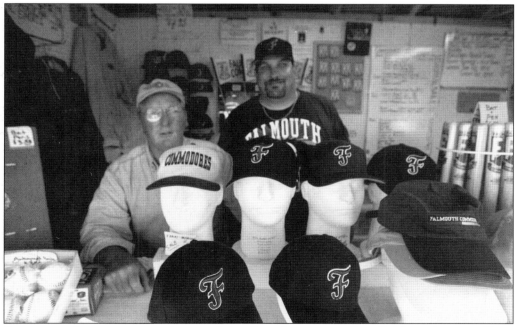

Souvenir and concession stands around the Cape League are all staffed by volunteers. Here, Jerry Reilly (left) and David Leferman stand ready to supply fans with the latest Falmouth Commodore gear. (Photograph by Dan Webb, courtesy Falmouth Enterprise.)

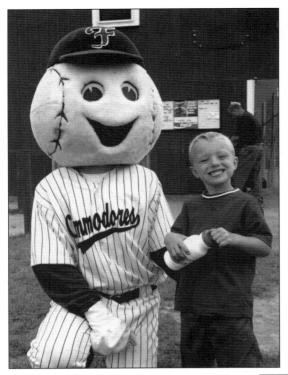

The Falmouth Commodores mascot, Homer, poses with a young fan. (Photograph by Dan Webb, courtesy Falmouth Enterprise.)

The Orleans Cardinals mascot helps keep the fans entertained. Eastham resident George Hoskey has been the big red bird since 1999. (Courtesy Sean Walsh.)

Before a Yarmouth-Dennis game in 2001, local resident Keegan Colmer of Yarmouth sings the national anthem. Kids play a big role in the Cape League. They work as bat boys and girls, work the refreshment stands, sing the anthem, and are some of the league's biggest fans. (Courtesy Sean Walsh.)

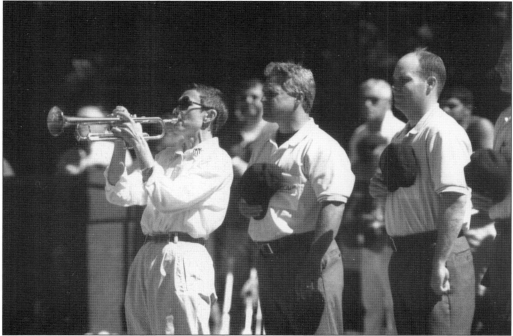

Beverly Donheiser performs the national anthem before a Cotuit Kettleers game at Lowell Park. (Photograph by Frank Finn, courtesy Cape Cod Sports Report.)

Tony Gwynn Jr. (San Diego State) played for Brewster in 2002. He played in the All-Star Game that year for the east and finished up the season as a member of the Cape Cod Baseball League all-league team. (Courtesy Sean Walsh.)

David Murphy (Baylor) of the Wareham Gatemen was the first-round pick of the Boston Red Sox in the 2003 June draft. He hit .304 in 2002 for Wareham, played in the All-Star Game, and made the all-league team that year. (Courtesy Sean Walsh.)